Miami-Dade Community College

Landforms of Southern Utah
A Photographic Exploration

RICHARD L. ORNDORFF

AND

DAVID G. FUTEY

D1059976

2007

MOUNTAIN PRESS PUBLISHING COMPANY

MISSOULA, MONTANA

QE
170
.S68
O76
2007
c.1

© 2007 by Richard L. Orndorff and David G. Futey

First Printing, August 2007
All rights reserved

Photos © 2007 by Richard L. Orndorff and David G. Futey

Front cover photograph © 2007 by David G. Futey:
Mushroom rocks in the Paria River basin in Grand Staircase–Escalante National Monument

Back cover photographs © 2007 by the authors
Top: *Polygonal jointing in volcanic tuff at Fremont Indian State Park*
Bottom: *Easily eroded sediments in the Paria River basin*

Maps were constructed using high-resolution elevation data from the
National Elevation Dataset maintained by the U.S. Geological Survey.

LIBRARY OF CONGRESS CATALOGING-IN-PUBLICATION DATA

Orndorff, Richard L.
 Landforms of southern Utah : a photographic exploration / Richard L. Orndorff and David G. Futey.
 p. cm.
 Includes index.
 ISBN 978-0-87842-539-6 (pbk. : alk. paper)
 1. Geology—Utah 2. Formations (Geology)—Utah. 3. Geoparks—Utah. 4. National parks and reserves—Utah. 5. Parks—Utah. I. Futey, David G., 1959– II. Title.
 QE170.S68O76 2007
 557.92—dc22

 2007018869

PRINTED IN HONG KONG

$15.00 1466595

Mountain Press Publishing Company
P.O. Box 2399 • Missoula, Montana 59806
(406) 728-1900

A landscape, like a man or woman, acquires character through time and endurance.
—Edward Abbey, *Vox Clamantis in Deserto*

Both the grand and the intimate aspects of nature can be revealed in the expressive photograph. Both can stir enduring affirmations and discoveries, and can surely help the spectator in his search for identification with the vast world of natural beauty and the wonder surrounding him.
—Ansel Adams

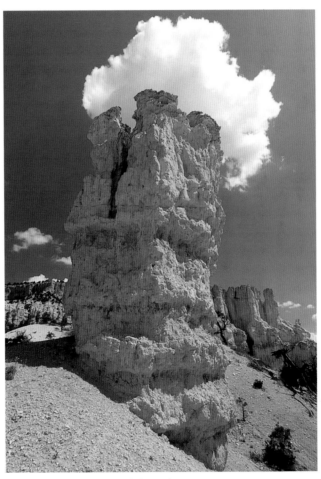

*A hoodoo of the Claron Formation
at Bryce Canyon National Park*

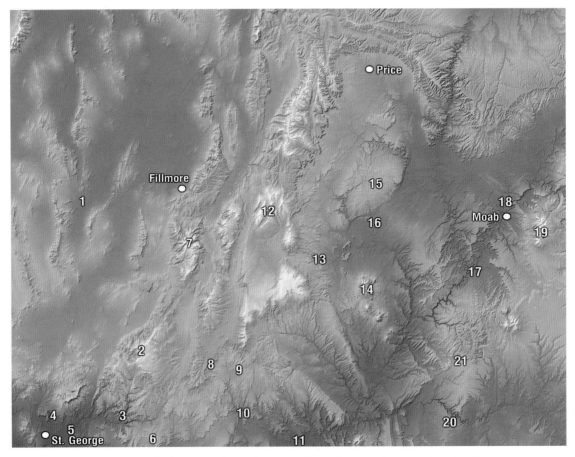

Shaded-relief image of southern Utah with sites discussed in book

1. Basin and Range
2. Brian Head, Hurricane Cliffs, and Cedar Breaks
3. Zion National Park
4. Snow Canyon State Park
5. Virgin Anticline
6. Coral Pink Sand Dunes State Park
7. Tushar Mountains

8. Bryce Canyon National Park
9. Kodachrome Basin State Park
10. Grand Staircase–Escalante National Monument
11. Lake Powell
12. Fish Lake
13. Capitol Reef National Park
14. Henry Mountains
15. San Rafael Swell

16. Goblin Valley State Park
17. Canyonlands National Park
18. Arches National Park
19. La Sal Mountains
20. Monument Valley and Valley of the Gods
21. Natural Bridges National Monument

Contents

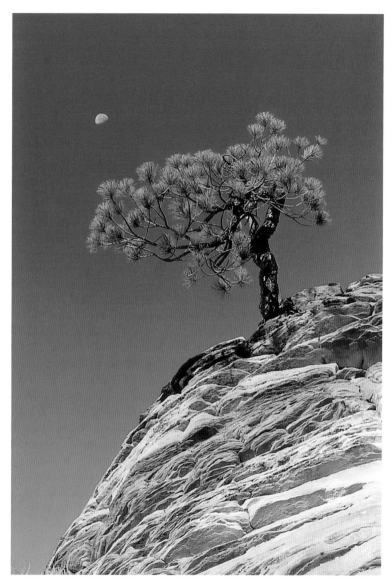

*Piñon pine growing from crossbedded and jointed
Navajo Sandstone in Zion National Park*

Preface

A few years ago, we hiked in the La Sal Mountains with another geologist to see the alpine landscape and visit some old mines. Our goal was an unnamed 12,163-foot peak southwest of Mount Waas, but the trailhead in Miners Basin was only accessible via a four-wheel-drive road, and we reasoned—correctly we think—that the rental car agency would notice if we broke an axle or otherwise mutilated our powder blue Buick. The only other option was to begin our trek at an elevation of 9,400 feet in a neighboring valley. That meant a much longer, more difficult hike because we had to surmount an intervening 11,000-foot ridge, but it seemed like a reasonable plan.

We worked our way over the ridge into Miners Basin and then followed an old trail upward—wagon ruts were still visible in some places. We diverted from the trail to poke around in long-abandoned mines and marvel at the hardy folks who dug into talus slopes so steep we could barely stand upright. We reached the mountaintop and made a decision. It should be noted that peaks, with thin air to breathe and cold wind whipping at your skin, are not good places to make decisions. From our high viewpoint, it appeared that we could follow a ridgeline south and west and descend to our starting point without having to go back up and down that damned ridge. We did note that there was another peak we'd need to surmount just to the south, and three distant bumps on the ridgeline.

We set off south across a narrow ridge and up the neighboring peak. From there we traveled west down a scree slope and then up the first of the three small peaks. We were hiking on large, sharp blocks of weathered rock that tilted and slid with our weight—slow, tedious work for creaky fellows like us. Out of breath and in worsening spirits, we reached the apex of that first bump then entered a forested saddle and promptly got lost. The topography was more complicated than it appeared from a distance, and among us we had neither compass nor map. After stumbling around for an hour, we reluctantly retraced our steps back up the peak we had just descended and drew a map in a notebook that allowed us to eventually find our way over two more small peaks and back to the original trail. We discovered later, while eating fine barbecue at a restaurant in Moab, that in avoiding a single 11,000-foot ridge, we had climbed an additional 12,000-foot peak and three other 11,000-foot peaks, turning a day hike into a fifteen-hour ordeal.

It seems like every trip into southern Utah produces a story of one sort or another. Edward Abbey wrote, "What draws us into the desert is the search for something intimate in the remote." The intimate is the human story, and making those stories requires interacting with a landscape. We hope the geologic stories, photographs, and maps in this book encourage you to go out and make some stories of your own.

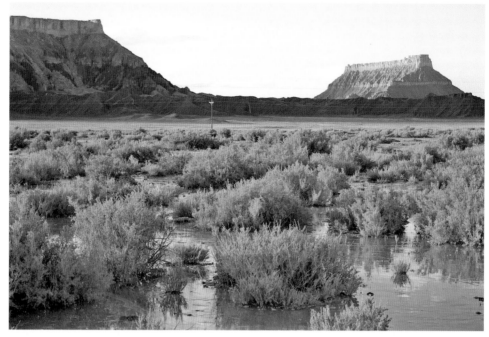

View to the north over desert flooded by the Fremont River with North Caineville Mesa (left) and Factory Butte (right) near Capitol Reef National Park

Church Rock, carved from Entrada Sandstone, north of Monticello along US 91

Colorful, nonresistant Morrison Formation in the foreground along the Burr Trail with resistant Dakota Sandstone on the skyline

Landforms and Landscapes

Southern Utah is filled with diverse and colorful landforms—from deep canyons to mountain peaks, from volcanic cones to weathered arches, and from modern sand dunes to ancient dunes preserved in 200-million-year-old rock. Landforms are geologic features that result from a combination of rock type, climate, and time. Rocks can be igneous (those that form from the solidification of magma), sedimentary (from weathered remains of preexisting rock), or metamorphic (from alteration by heat and pressure).

They may lie in flat beds, or they may be folded or fractured. Rocks may have formed at considerable depth, or they may have formed at the surface, perhaps as lava flows or by deposition of sediment. Once exposed at the surface, rocks are chemically and physically broken down, a set of climate-controlled processes called *weathering*. Altered fragments are then carried away by water, wind, or ice, a process called *erosion*.

When looking at landforms, it is important to remember that features often develop over

long periods of time and offer clues not just to the present but also to the geologic history of a region. For example, beautiful glacially carved valleys are present in the mountains of southern Utah, yet no glaciers exist there today. At the height of the last ice age, about 20,000 years ago, glaciers eroded vast amounts of rock from the flanks of high mountains, creating deep, broad valleys.

Landforms often reflect the relative resistance of a particular rock unit to weathering and erosion. Resistant rock, such as sandstone or basalt, maintains steep slopes or sheer cliffs. Nonresistant rock, such as shale or siltstone, forms gentle slopes. When horizontal layers of resistant and nonresistant rock are exposed at the surface, they form alternating cliffs and slopes.

Linear features in the landscape often indicate fractures or faults. Rock weakens and fractures when it is bent into broad upwarping folds called *anticlines* or downwarping folds called *synclines*. Earthquakes, the sudden release of stored energy, also fracture and weaken rock. When rock on one side of a fracture moves up, down, or sideways relative to rock on the other side, we call the fracture a *fault*. Weathering and erosion attack zones of weakness, creating slot canyons, fins, and other landforms.

If a landform is a single feature, what then is a landscape? A landscape is a collection of landforms that can be viewed together, from a hillside or even from space. Landforms within a landscape have some unifying theme related to rock type, climate, or age. Landforms that look dissimilar may in fact be part of the same landscape if the underlying processes that created the landforms are related. A landscape may encompass a valley, a mountain, or an entire region, depending on how widespread the unifying theme is. In this book we have chosen to present landscapes in shaded-relief maps. We discuss the geologic processes that shaped the landscapes and share photographs of associated landforms.

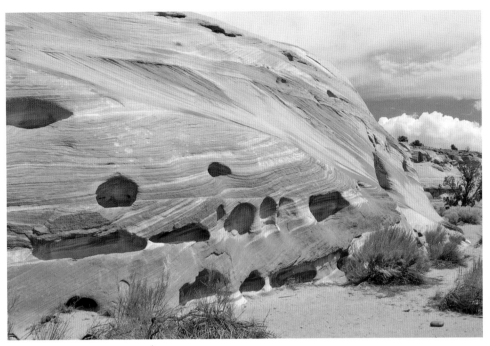

Crossbedded Page Sandstone outcrop in the Paria River Basin

Southern Utah's Geologic Past

Landscapes reflect changes that have taken place over a span of geologic time, and they continue to change in response to modern geologic processes and events. Most changes in the geologic past took place slowly over long periods of time, but some events, like explosive volcanic eruptions or meteorite impacts, produced sudden and lasting changes on earth. Geologists organize earth's 4.5-billion-year-long history into the geologic timescale. We present an extreme simplification of the timescale here, just enough to give you a sense of the timing of geologic events that affected southern Utah.

The Precambrian Era, from the time earth formed to 540 million years ago, represents almost 90 percent of earth's history, but Precambrian rocks are rare in southern Utah. Those that do exist are so altered by later geologic events that it is difficult to derive much information about the specific environments in which they formed. Most Precambrian organisms lacked hard parts, so fossil evidence from that time is scarce.

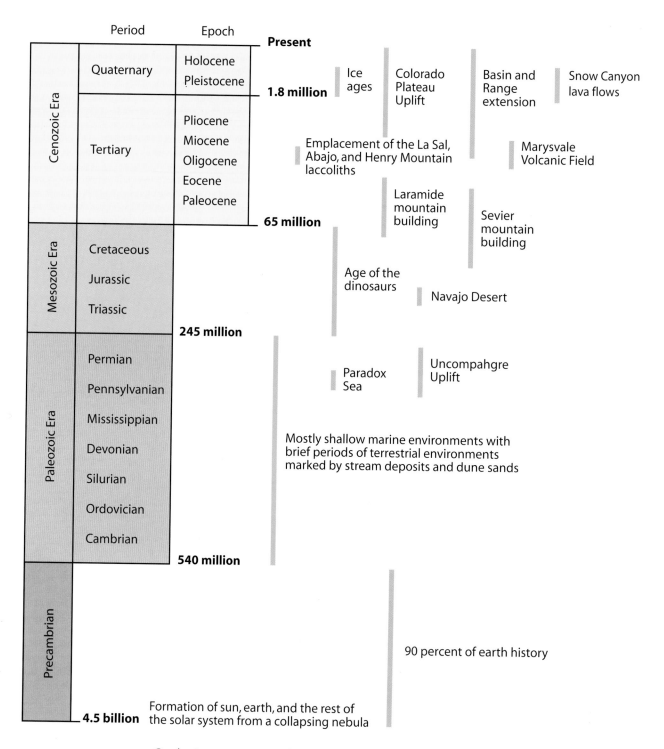

Period	Epoch		

Present

| Cenozoic Era | Quaternary | Holocene |
| | | Pleistocene |

1.8 million

	Tertiary	Pliocene
		Miocene
		Oligocene
		Eocene
		Paleocene

65 million

Mesozoic Era	Cretaceous
	Jurassic
	Triassic

245 million

Paleozoic Era	Permian
	Pennsylvanian
	Mississippian
	Devonian
	Silurian
	Ordovician
	Cambrian

540 million

Precambrian

4.5 billion

Ice ages

Colorado Plateau Uplift

Basin and Range extension

Snow Canyon lava flows

Emplacement of the La Sal, Abajo, and Henry Mountain laccoliths

Marysvale Volcanic Field

Laramide mountain building

Sevier mountain building

Age of the dinosaurs

Navajo Desert

Paradox Sea

Uncompahgre Uplift

Mostly shallow marine environments with brief periods of terrestrial environments marked by stream deposits and dune sands

90 percent of earth history

Formation of sun, earth, and the rest of the solar system from a collapsing nebula

Geologic events in southern Utah on the geologic timescale

TERTIARY ROCKS
Claron Formation

CRETACEOUS ROCKS
Mesaverde Sandstone
Mancos Shale
Dakota Sandstone

JURASSIC ROCKS
Morrison Formation
Curtis Formation
Entrada Sandstone
Carmel Formation
Page Sandstone
Navajo Sandstone
Kayenta Limestone
Wingate Sandstone

TRIASSIC ROCKS
Chinle Shale
Shinarump Formation
Moenkopi Formation

PERMIAN ROCKS
Kaibab Limestone
White Rim Sandstone
De Chelly Sandstone
Organ Rock Shale
Cedar Mesa Sandstone
Halgaito Shale

Important sedimentary rock formations in southern Utah, from youngest (top) *to oldest* (bottom)

The Precambrian ended with the beginning of the Phanerozoic, which means "visible life," when the world's oceans saw a sudden increase in the number and type of shelled organisms. The shells are well-preserved in the fossil record.

Phanerozoic time begins with the Paleozoic Era, which extends from 540 to 245 million years ago. The Paleozoic rock record shows that western Utah was covered by a shallow tropical sea and eastern Utah was a flat plain on the western edge of a continent. Rocks from this time include marine limestones and sandstones formed from stream channels and dunes. About 300 million years ago, an inland ocean called the Paradox Sea formed in a deepening basin near the edge of the continent. East of the Paradox Sea, the Ancestral Rockies grew during an event that geologists call the Uncompaghre Uplift.

The Mesozoic Era, from 245 to 65 million years ago, was the age of the dinosaurs, and numerous trackways in southern Utah attest to their presence. During middle Mesozoic time, southern Utah was a vast, dry region that geologists call the Navajo Desert. Beginning about 140 million years ago, western North America saw the onset of geologic upheaval as the westward-moving North American Plate collided with tectonic plates farther west. First, between 140 and 50 million years ago, compression associated with the Sevier mountain building event created great thrust faults and built the modern Rockies to the east. Next, between 80 and 35 million years ago, regional east-west compression from the Laramide mountain building event caused deep-seated blocks of rock to rise, draped by layers of younger sedimentary rock.

The Cenozoic Era extends from 65 million years ago to the present. Sedimentary rocks that were deposited during early Cenozoic time were

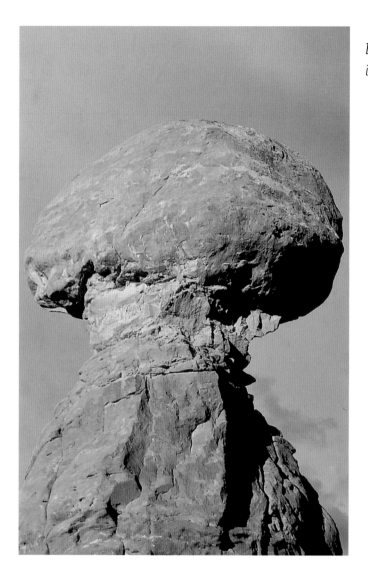

Balanced rock of Entrada Sandstone
in Arches National Park

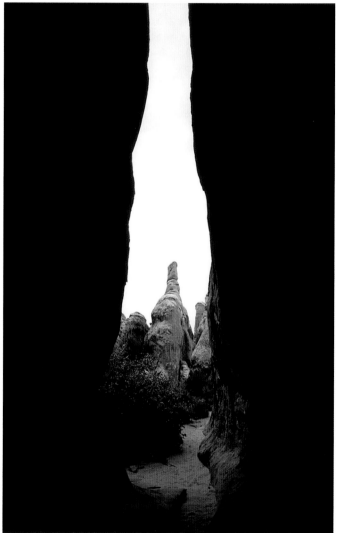

Tight passageway through the Fiery
Furnace in Arches National Park

eroded from mountains built during the two late Mesozoic events. About 30 million years ago, magma intruded between layers of sedimentary rock and cooled beneath the surface, forming igneous rock. Later, erosion of overlying sedimentary rock layers revealed these resistant igneous bodies, which now form the Henry, Abajo, and La Sal Mountains. At the same time, massive eruptions from the Marysvale Volcanic Field covered much of southern Utah with ash. Basin and Range extension also began pulling the southwestern United States apart about 30 million years ago, although this process didn't affect southern Utah until about 20 million years ago. Uplift of the Colorado Plateau began about 6 million years ago, forcing streams in the Colorado River basin to carve deep canyons. During the Pleistocene Epoch, beginning 1.8 million years ago, global climate change produced alternating warm and cool periods called glacial and interglacial stages. About 15,000 years ago, at the end of the latest glacial stage, Glacial Lake Bonneville reached its maximum extent and was a much larger lake than the shrunken remnant that is now Great Salt Lake.

Basin and Range

Southwestern Utah is part of the Basin and Range, a region in the western United States characterized by north-south-oriented valleys and mountains. About 30 million years ago, semimolten rock deep within the earth began welling up beneath the Basin and Range, doming and thinning surface rock. As the brittle crust at the earth's surface stretched to the east and west, it broke along north-south-trending faults.

Huge masses of rock dropped down along the faults, a small amount with each earthquake but adding up over time to thousands of feet. The down-dropped valleys alternate with mountains in the Basin and Range, and movement along the faults continues to this day. The basins have filled with thousands of feet of sediment shed from the mountains along each side.

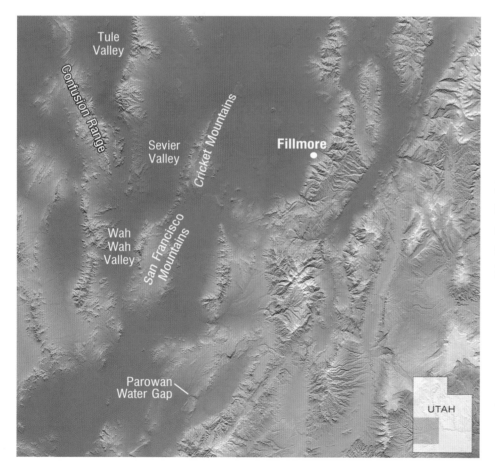

Shaded-relief map of mountains and valleys in southern Utah on the eastern edge of the Basin and Range

San Francisco Mountains from the ruins of Frisco, a mining town that was built after the discovery of lead and silver ore there in 1875

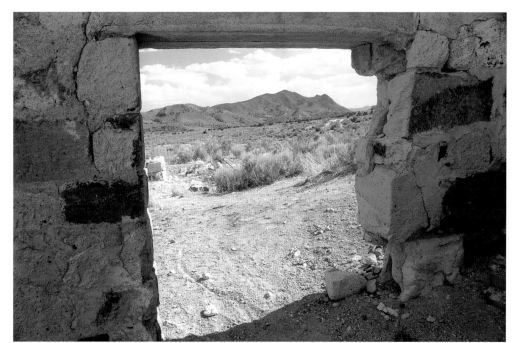

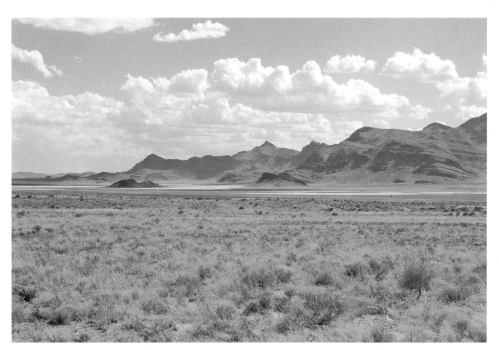

View to the southwest across the Tule Valley toward the base of the Confusion Range

Shorelines of Glacial Lake Bonneville

The Pleistocene Epoch, the last 1.8 million years of earth's history, featured cool glacial stages that alternated with warm interglacial stages. The last glacial stage peaked about 20,000 years ago, when a continental ice sheet extended south into the northern United States from Canada. In the southwestern United States, cooler, wetter conditions produced glaciers in the high mountains and large lakes in the currently dry valleys. One such lake, Glacial Lake Bonneville, filled the valleys of western Utah. It was 1,000 feet deep and covered 20,000 square miles, extending from

Wave-polished boulders in the Cricket Mountains with a wave-cut terrace visible at the foot of the mountains in the distance (upper right)

View to the south at a fairly young gravel beach on the Sevier Lake Playa

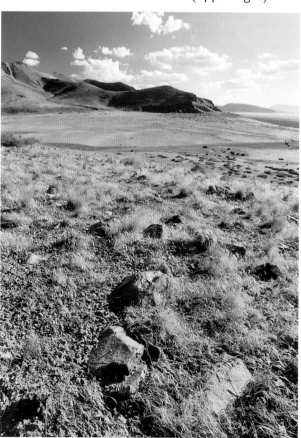

southern Idaho south into the Tule, Sevier, and Wah Wah Valleys of southern Utah. During extended periods when the lake level was stable, waves carved flat terraces into hillsides, polished rocks, and deposited beach sand and gravel. The highest lake surface was 5,090 feet above sea level—the elevation of a northern spillway into the Snake River drainage in Idaho. Today, all that remains of Glacial Lake Bonneville is Great Salt Lake, Utah Lake, and the many salt flats that decorate valley floors throughout Utah.

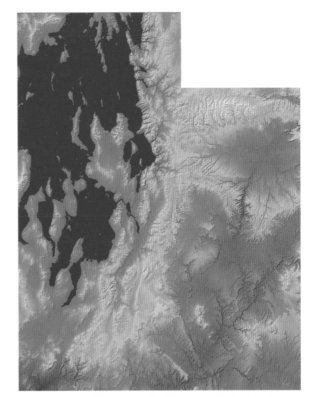

Extent of Glacial Lake Bonneville in Utah

View to the north at a wave-cut terrace in the Sevier Valley

Playas

Most of the valleys in Utah's Basin and Range are closed basins—water that flows into them does not drain out. Lakes, including Glacial Lake Bonneville, filled these basins during the last glacial stage and peaked in size about 15,000 years ago. As conditions became warmer and drier in the last 15,000 years, water evaporated from the lakes, concentrating dissolved minerals, mostly a variety of salts, in the remaining water. When the lakes completely dried up, salts precipitated, forming a light-colored surface called a *playa*. Few plants can grow on this salty soil. Some basins in southwestern Utah hold water in the spring due to snowmelt from adjacent mountains. By summer this water evaporates, leaving more precipitated minerals behind.

Low-angle shaded-relief view to the south at Sevier Lake and Wah Wah Playas in the Basin and Range

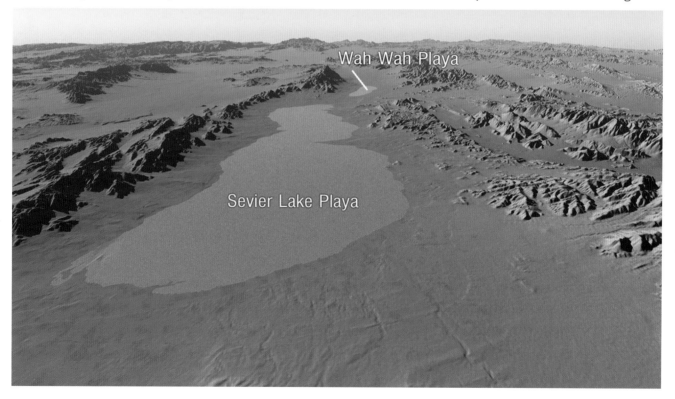

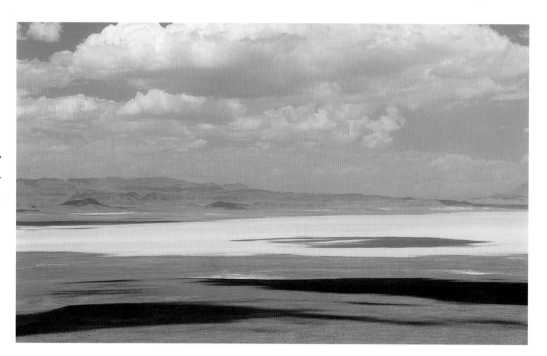

*View to the
north over Sevier
Lake Playa*

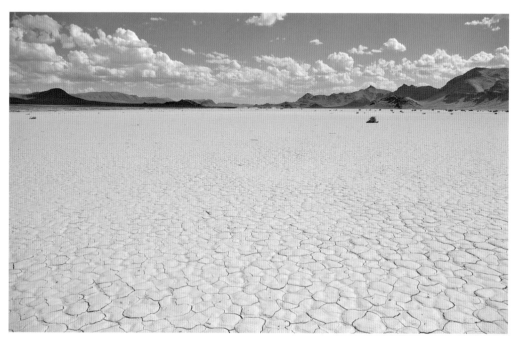

*View to the
southwest over
Tule Valley Playa*

Mud Cracks

Mud cracks form when saturated, fine-grained sediments dry and shrink. Playa sediment has clay minerals and salt, both of which absorb water and swell. When a lake recedes or when shallow water evaporates, sediment is exposed to the atmosphere and dries out. Clay minerals and salts release water and shrink, producing a pattern of polygonal cracks on the surface. If there is a thin layer of fine-grained sediment on top of a layer of sand or silt, the edges of the polygons tend to curl upward. Wind blows over playa surfaces and erodes sediment from the edges of the polygons, rounding and smoothing the mud cracks.

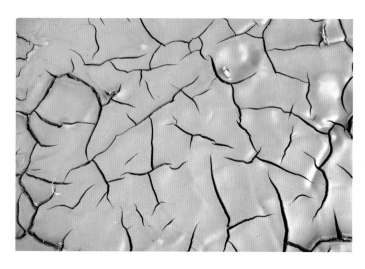

Mud cracks forming on a still-moist surface

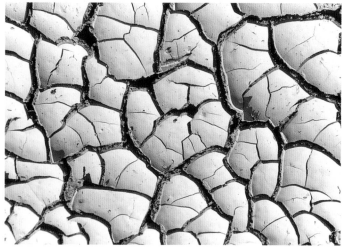

Mud cracks with curled edges

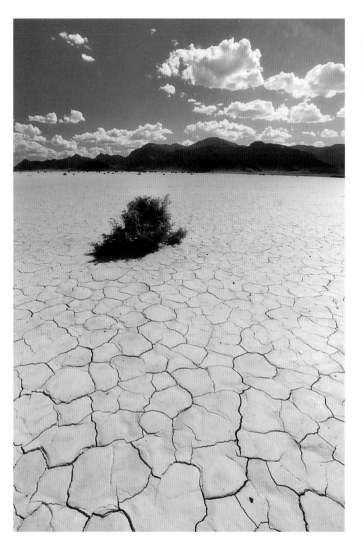

Mud cracks on the Tule Valley Playa superimposed over faint impressions of older cracks

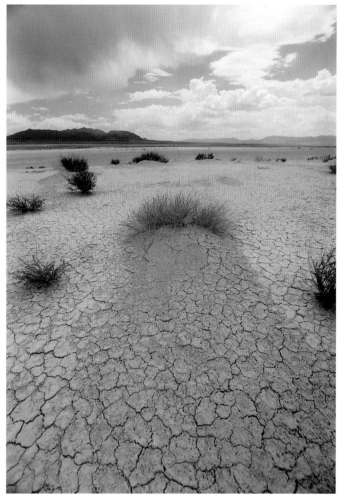

Windblown sediment trapped behind a plant on the Sevier Lake Playa

Parowan Water Gap

The Parowan Water Gap cuts across the Red Hills, which are composed of sedimentary rock of Tertiary age with lava flows of Quaternary age in the southern part. The Red Hills, a Basin and Range fault block, rose beneath a preexisting stream channel that flowed from the highlands in the east to the low basin in the west. As the fault block rose, the stream eroded downward like a knife slicing through bread, forming the water gap. At some point, the rate of uplift increased beyond the stream's ability to cut downward, and the Red Hills impounded the stream, forming a shallow lake. The drying, warmer climate of the last 10,000 years evaporated the water and left behind a playa called Little Salt Lake.

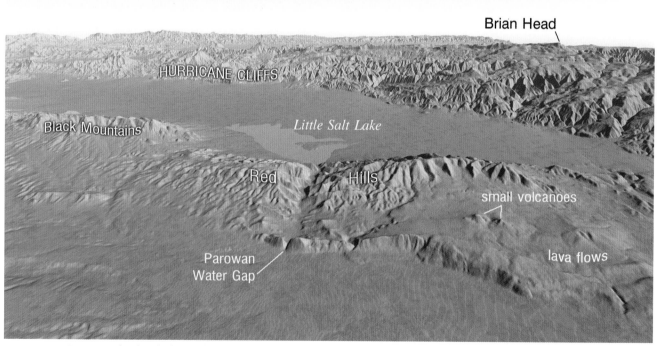

Low-angle shaded-relief view to the east across the Parowan Water Gap and Little Salt Lake

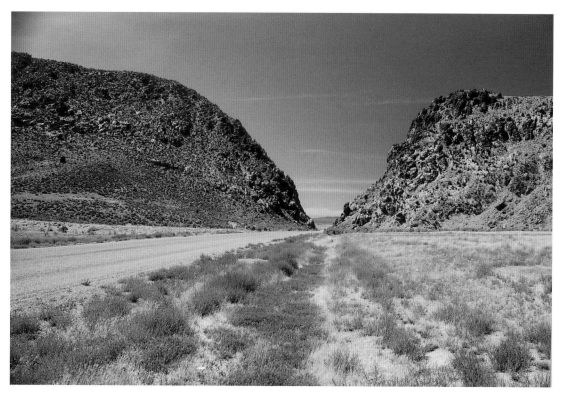

View to the east through the western end of the Parowan Water Gap

Brian Head, Hurricane Cliffs, and Cedar Breaks

Low desert of the Basin and Range to the west steps up to the central Colorado Plateau to the east in a series of three faults. From west to east, they are the Hurricane, Sevier, and Paunsaugunt Faults. All three faults are oriented north-south, with down-dropped western blocks and up-thrown eastern blocks. The Hurricane Fault, with the greatest length and most uplift of the three, forms the 1,000-foot-high Hurricane Cliffs, a 160-mile-long escarpment. Offset lava flows and recent earthquakes are clear reminders that these faults are still active.

Brian Head, an 11,307-foot peak, sits at the top of the Hurricane Cliffs on the western edge of the Markagunt Plateau. Erosion has carved away at the cliffs, so Brian Head, several miles east of the Hurricane Fault, truly does mark the high edge of the cliffs. Brian Head is capped by the approximately 24-million-year-old Leach Canyon Formation, a rock made of welded ash from a series of eruptions associated with ancient volcanic activity at Caliente, Nevada. Brian Head offers stunning views into the Basin and Range to the west, Cedar Breaks to the south, and the forested Markagunt Plateau to the east.

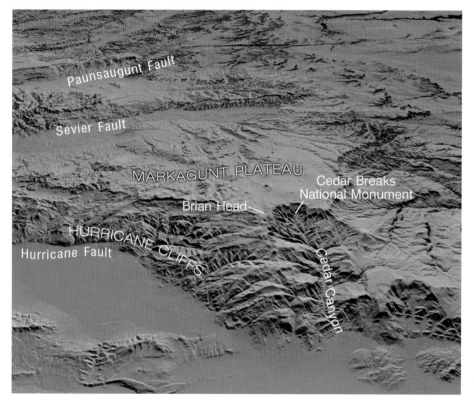

Low-angle shaded-relief view to the east across the Hurricane, Sevier, and Paunsaugunt Faults

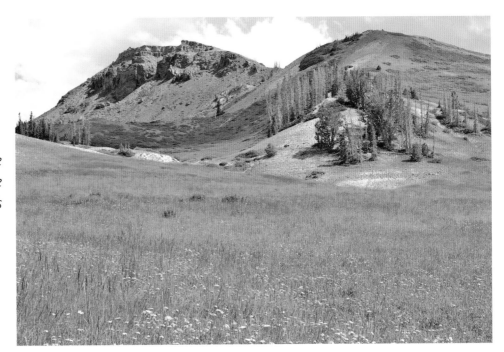

Brian Head, the high point of the Hurricane Cliffs

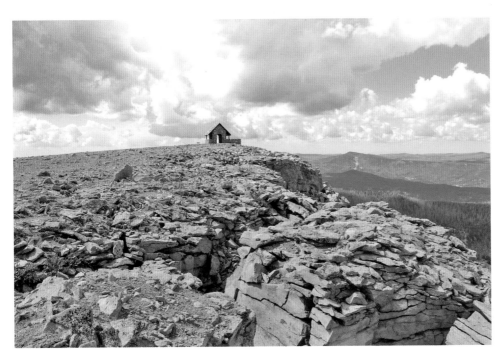

Fractured, welded volcanic ash exposed at the summit of Brian Head

Cedar Breaks National Monument

Resistant volcanic rock caps much of the Markagunt Plateau. At the edge of the Hurricane Cliffs, Ashdown Creek, a tributary to Coal Creek that flows west in Cedar Canyon, has sculpted an amphitheater into less resistant rock below the volcanic caprock. The most noticeable rock, and the one that makes up most of Cedar Breaks National Monument, is the bright red and white Claron Formation of Tertiary age, the same unit we see in Bryce Canyon and Red Canyon. Here, in a process called *headward erosion*, Ashdown Creek and its many small tributaries have carved channels, gullies, and rills into the soft rock. Erosion of the weaker underlying rock has undercut the volcanic rock on the plateau rim. Over time, the overhanging rock has collapsed, the channels have lengthened, and the Cedar Breaks amphitheater has migrated progressively eastward from the Hurricane Fault.

Hoodoos of Claron Formation at Cedar Breaks National Monument

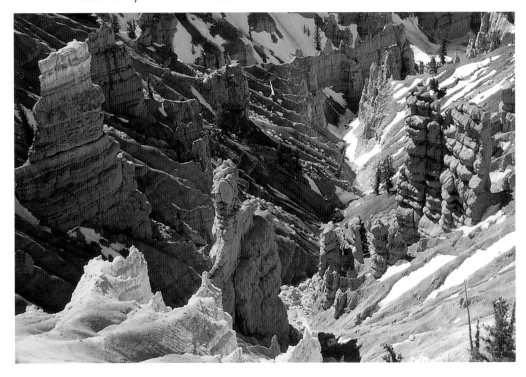

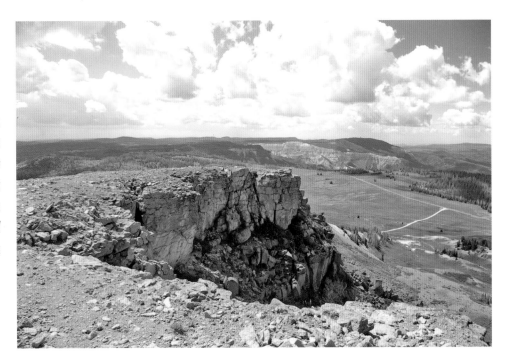

View to the south from Brian Head with reddish rock of Cedar Breaks National Monument visible in the distance on the edge of the forested Markagunt Plateau

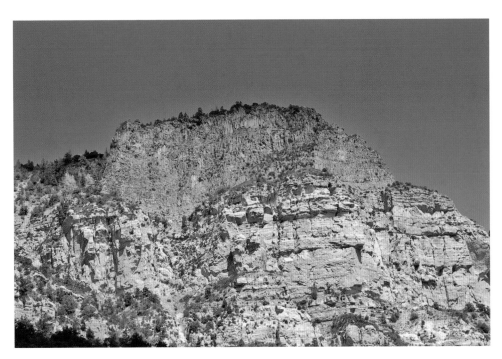

Dark gray lava flow capping sedimentary rock in Cedar Canyon at the west edge of the Markagunt Plateau

Zion National Park

Rock at the earth's surface behaves as a brittle material—it fractures when stresses exceed its strength. Because Zion National Park sits in the transition zone between the Basin and Range and the Colorado Plateau, the sedimentary rock exposed there experienced two recent episodes of extreme stress. Beginning about 30 million years ago, regional stretching created the Basin and Range. About 6 million years ago, the Colorado Plateau began rising. The combination of these two events created many large fractures, also called *joints*, that trend north-northwest and can be seen on the shaded-relief map. There are also smaller fracture systems related to the same events. The Virgin River cut a section of Zion Canyon along some of these joints as the Markagunt Plateau was uplifted between the Hurricane and Sevier Faults.

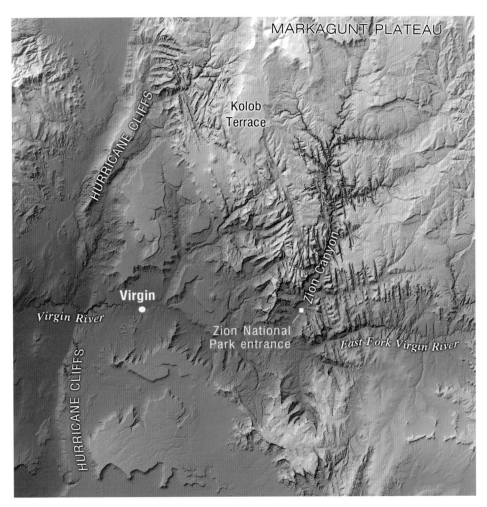

MARKAGUNT PLATEAU

HURRICANE CLIFFS

Kolob Terrace

Zion Canyon

Virgin

Virgin River

Zion National Park entrance

East Fork Virgin River

HURRICANE CLIFFS

Shaded-relief map with large north-northwest-trending fractures near Zion National Park

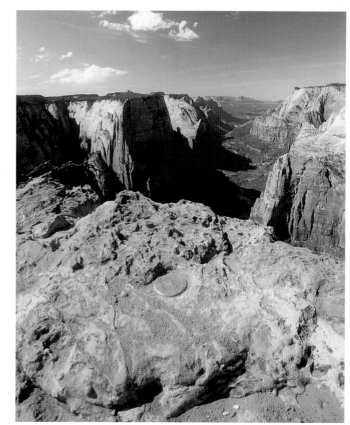

U.S. Geological Survey benchmark along the East Rim Trail above the Virgin River canyon in Zion National Park

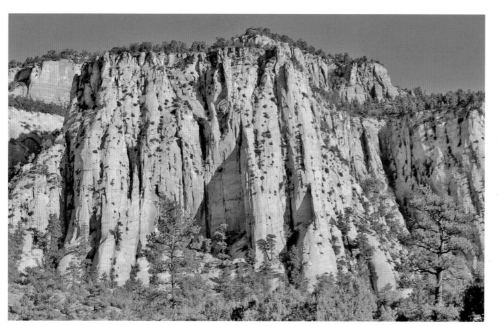

Vertical fractures in Navajo Sandstone in Zion National Park

Crossbeds

The Navajo Sandstone that forms the high canyon walls in Zion National Park was deposited 200 million years ago in a sand sea, a large desert region filled with dunes similar to Africa's modern Sahara Desert. Wind blows sand up the shallow windward face of dunes, the side from which the wind blows, and the sand then cascades down the steeper lee face. Movement down the lee face imparts an internal structure of angled layers within dunes called *crossbeds*. These crossbeds were preserved when the sand grains were cemented together, forming the Navajo Sandstone. The crossbeds tell us about wind directions in that ancient desert. Calcite and iron oxide cement give the canyon walls their varying buff to red colors.

Crossbedded Navajo Sandstone at Zion National Park

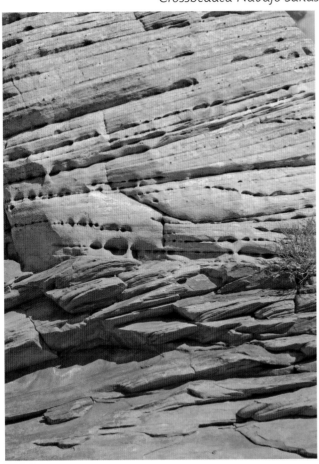
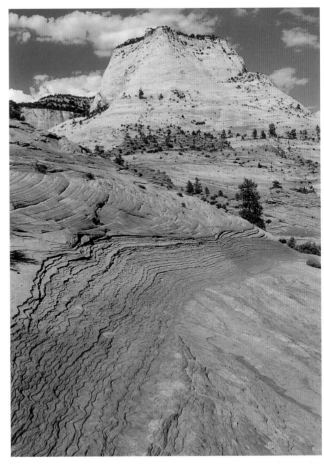

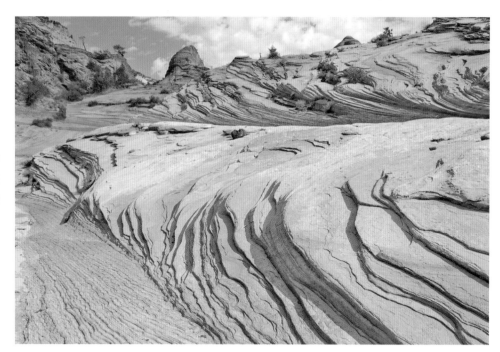

Crossbedded Navajo Sandstone at Zion National Park

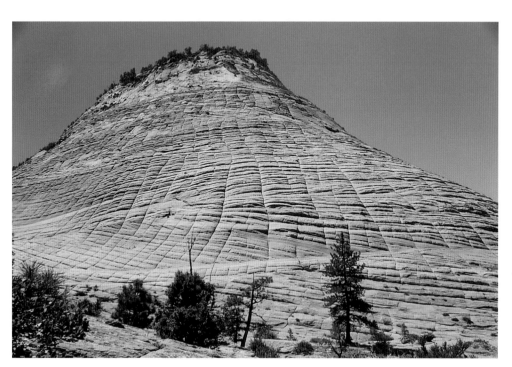

Vertical fractures cutting the crossbedded Navajo Sandstone at Checkerboard Mesa

Snow Canyon State Park

Geologists recognize three lava flows in Snow Canyon on the southwest flank of the Pine Valley Mountains: the 1.4-million-year-old Lava Ridge flow, the 1.1-million-year-old Snow Canyon Overlook flow, and the 20,000-year-old Santa Clara flow. The lava flows make a series of stair steps down to the west. In each case, lava flowed from east to west into a broad valley formed previously by stream erosion. And in each case, hardened lava, a rock called *basalt*, pushed the stream farther west, where it eroded a new, deeper channel into the Navajo Sandstone. In most cases, a geologist can look at lava flows and determine their relative ages based on position—

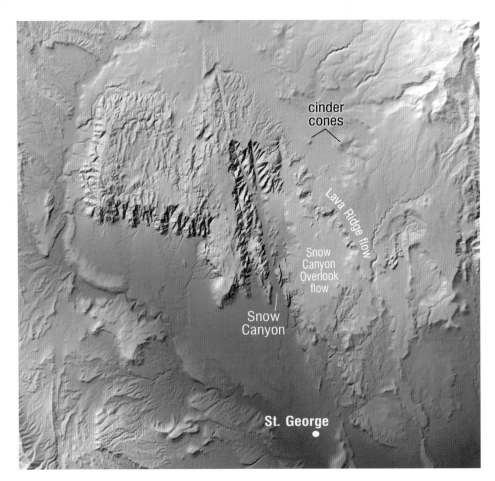

Shaded-relief map of Snow Canyon

higher, younger flows cover older, lower flows. At Snow Canyon, however, the oldest flow is at the highest elevation and the youngest flow is at the lowest elevation, because each new flow filled in a deep stream channel eroded during the time between eruptions of lava. Scattered cinder cones, small volcanoes, formed at the same time as the recent Santa Clara flow. Cinder cones are fairly delicate features, and none survive from the earlier eruptions.

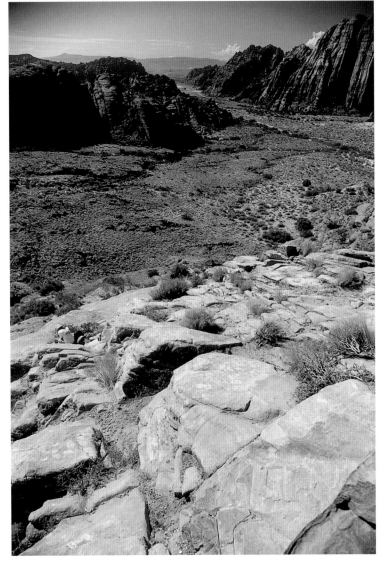

Navajo Sandstone in the foreground and in canyon walls and the Santa Clara lava flow in the middle distance at Snow Canyon State Park

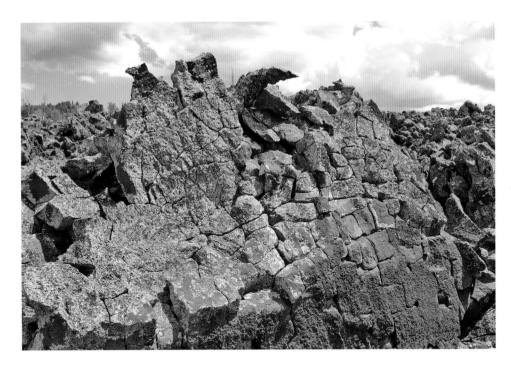

Fractured lava flow surface at Snow Canyon State Park

View to the south of cinder cone with lava flow at Snow Canyon

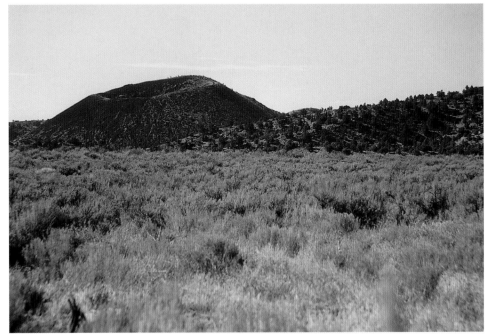

Virgin Anticline

Because sediment is deposited under the influence of gravity, most sedimentary rock layers are horizontal until uplift, faulting, or mountain building disturb them. At the Virgin Anticline, just southeast of the Pine Valley Mountains, the originally horizontal sedimentary rock layers were bent into a thirty-mile-long, northeast-trending fold called an *anticline*. Regional compression during the lengthy Sevier mountain building event folded these rocks sometime between 140 and 50 million years ago, but there is not enough information present to determine exactly when it occurred. Recent (geologically speaking) stream erosion has carved out the center of the fold and left behind the east- and west-dipping limbs that cradle Quail Creek Reservoir and Quail Creek State Park.

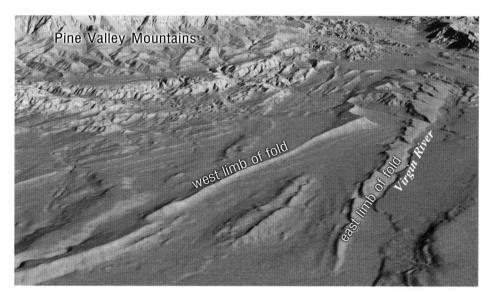

Low-angle shaded-relief view to the north across the Virgin Anticline

Coral Pink Sand Dunes State Park

Coral Pink Sand Dunes are six miles long and one-half mile wide. The dunes, mostly arc-shaped, fill an open valley and rise over a low escarpment formed by the Sevier Fault. Winds from the southwest have accelerated through narrow wind gaps to the south and west, carrying sand grains from weathered, red sandstones. Wind speeds slow in the broader valley, and the sand is deposited. The dunes are colored pink by the iron oxide that once cemented these grains into solid rock.

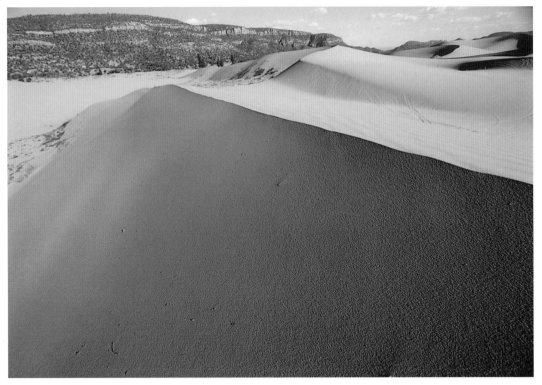

View to the south of Coral Pink Sand Dunes with a wind gap in the distance

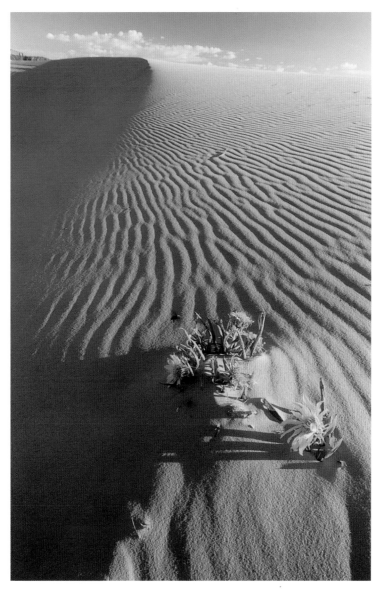

Rippled dune surface at Coral Pink Sand Dunes

Tushar Mountains

The Tushar Mountains are part of the Marysvale Volcanic Field, a set of five centers of volcanism in west-central Utah that sent huge quantities of searing ash into the atmosphere starting 30 million years ago. Much of that ash fell to the ground and fused into a rock called *tuff*. When the hot ash cooled and shrank, some tuff developed polygonal joints, a fracture system that forms mostly five- and six-sided columns. Fremont Indian State Park, on the north edge of the Tushar Mountains near Sevier Junction, is a good place to look at tuff. Sandstones and conglomerates that formed from weathered and eroded tuff later weathered into picturesque rock towers called *hoodoos*.

Movement of hot, ion-rich water released by cooling magma bodies changed the mineral characteristics of rock beneath the surface. Altered rock is now exposed at the surface in eroding slopes on Big Rock Candy Mountain, visible from U.S. 89 in Marysvale Canyon.

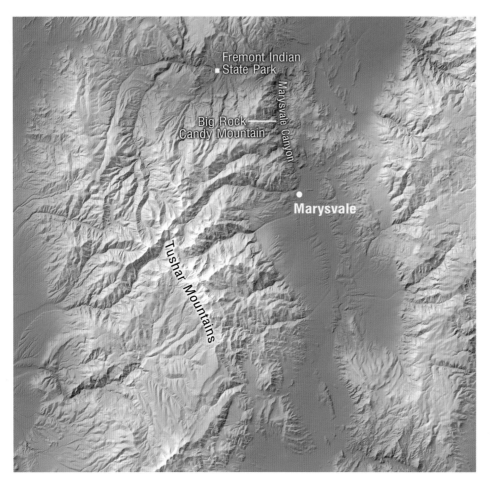

Shaded-relief map of the Tushar Mountains

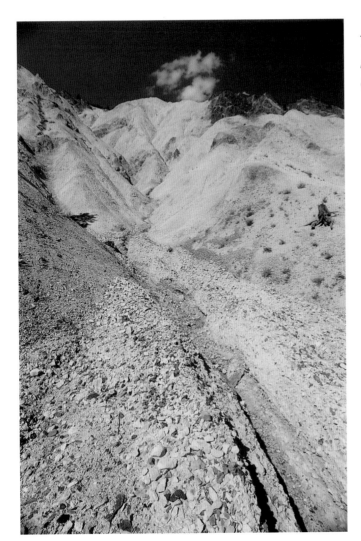

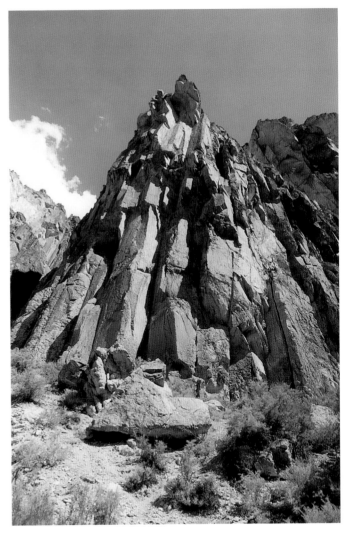

*Yellowish altered volcanic
rock exposed at Big Rock
Candy Mountain*

*Polygonal jointing in volcanic tuff
at Fremont Indian State Park*

Bryce Canyon National Park

Bryce Canyon National Park lies on the eastern edge of the Paunsaugunt Plateau, which is bounded by the Sevier Fault to the west and the Paunsaugunt Fault to the east. The Paria River and its tributaries have eroded the southeastern edge of the Paunsaugunt Plateau, creating the abrupt escarpment in the park. The highly eroded rimrock is the Claron Formation of Tertiary age, which contains many rock types, some of which are cemented with bright red iron oxide. Sandstone and conglomerate channels in the Claron were created by meandering streams, while siltstone and shale layers were floodplain deposits. Ancient soils contain root casts of the plants that grew in the broad, flat plains. Some limestones were probably calcium carbonate–rich layers in soil, while others may have formed in shallow lakes.

The sandstone, limestone, and conglomerate are well-cemented rock that resists erosion, and the shale and siltstone are poorly cemented rock that is easily eroded by running water. The presence of fractures, likely formed from plateau uplift, in these sedimentary layers has helped produce hoodoos, freestanding landforms made of resistant caprocks that protect less resistant pedestals from erosion.

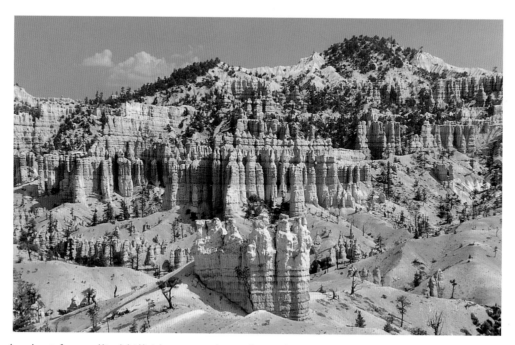

Largely plant-free gullied hillsides, a product of rapid erosion at Bryce Canyon National Park

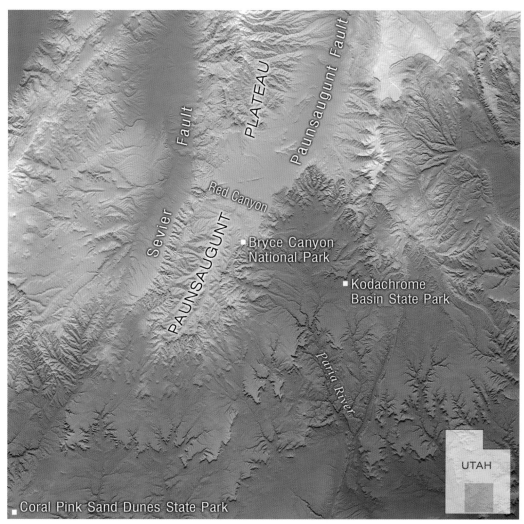

Shaded-relief map of Bryce Canyon National Park and vicinity

Red Canyon

The same collection of sandstone, conglomerate, siltstone, limestone, and shale beds of the bright red Claron Formation that we see at Bryce Canyon National Park has also created hoodoos at Red Canyon, on State Route 12 northwest of Bryce, but the geologic setting is different. Red Canyon sits on top of the north-trending Sevier Fault. At the western edge of Red Canyon, Quaternary basalt on the west side of the sloping fault surface rests against Tertiary Claron Formation on the east side. The younger basalt has been dragged downward along the west-sloping fault surface.

There has been 200 feet of movement along the fault since the basalt hardened from molten lava. This amount of offset in such a short amount of time suggests that the fault is still active.

View to southwest from a basalt ridge high above the Claron Formation of Red Canyon with the line of the Sevier Fault in the distance marked by the preference of trees for the stable basalt over the eroding Claron Formation

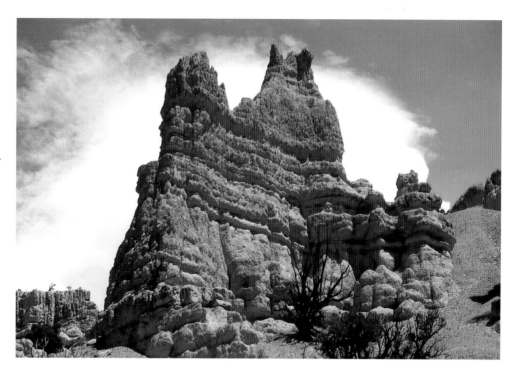

*Hoodoos of
Claron Formation
at Red Canyon*

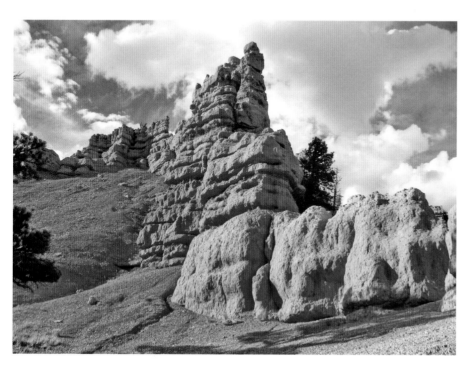

*Hoodoos of
Claron Formation
at Red Canyon*

Kodachrome Basin State Park

The name Kodachrome Basin was coined by a team of *National Geographic Magazine* photographers who were trying out a new type of color film. The rock colors, mostly red due to iron oxide cement, are intense, but the geologic story is more about the scattered rock towers than the colors. The towers are clastic dikes, the remains of a sand and gravel slurry that was emplaced from below into the Entrada and Carmel Sandstones of Jurassic age. Flow structures indicate that this slurry was forcibly injected into a network of large and small pipes, many of which are visible on exposed rock faces. Nobody knows why this happened, but geologists have several ideas. Pressure from the weight of overlying rock may have forced water trapped between impermeable layers to break through and shoot upward. Or ground shaking may have forced water and sediment upward, a process that is sometimes observed during large earthquakes. The clastic dikes are well cemented with the mineral calcite. When weathering and erosion peel away the encasing sandstone, the pipes are left as freestanding towers.

View to the south from Eagle's View Trail of clastic dikes standing tall above Kodachrome Basin

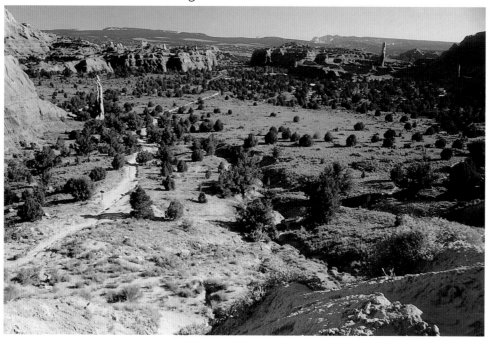

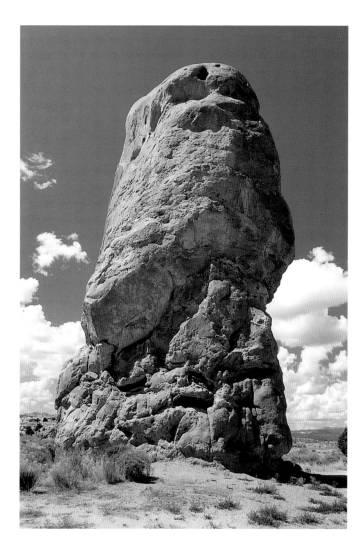

Chimney Rock, a clastic dike,
in Kodachrome Basin

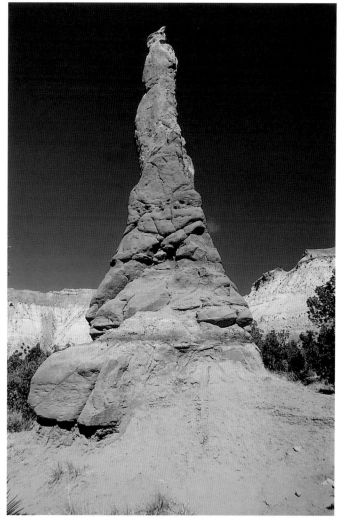

Clastic dike at Kodachrome
Basin with eroding slopes of
Carmel Sandstone in the distance

Grand Staircase–Escalante National Monument

Grand Staircase–Escalante National Monument, a vast high-desert region in south-central Utah, features a series of benches and cliffs that step down in elevation from near Bryce Canyon National Park in the north to Paria Canyon in the south. Many rock types and features are exposed, but sandstones are often the most visible because of their resistance to weathering (the chemical alteration and physical breakdown of exposed rock). They do weather, though, with dramatic results. Exposed sandstone faces are often covered by roughly circular pits that can vary in size from

Honeycombed sandstone on the Burr Trail in Grand Staircase–Escalante National Monument

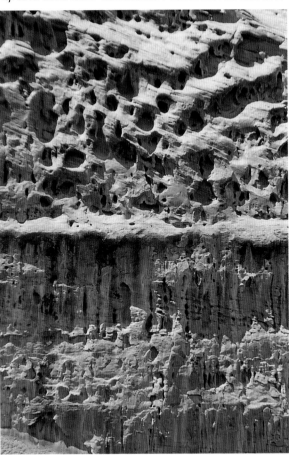

Arch in sandstone near Hole-in-the-Rock Road, southeast of Escalante

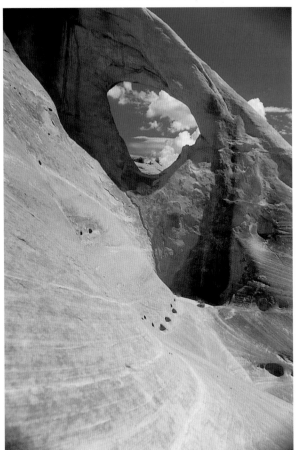

much less than an inch to tens of feet across. Geologists think that most pits form when windblown salt crystals wedge into the tiny pore spaces between the sand grains. When it rains, the salt crystals absorb water and expand, breaking sand grains free. More salt crystals lodge in the pore spaces, and then absorb water and expand, until the entire rock face is honeycombed with pits. Weathering pits are often aligned because layers within rock units create zones of weakness.

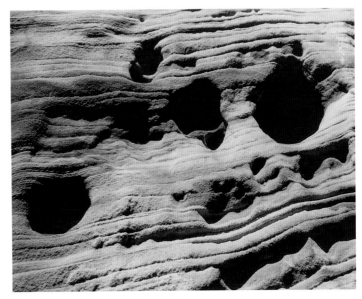

Weathered sandstone

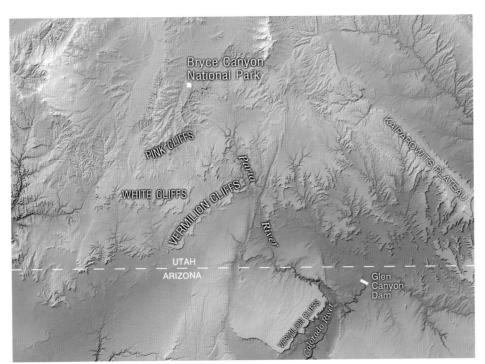

Shaded-relief map of the Paria River basin in Grand Staircase–Escalante National Monument

Slot Canyons of the Paria River Basin

The Paria (pah-REE-a) River joins the Colorado River below Glen Canyon Dam in northern Arizona. The Paria and its tributaries have eroded channels—some of which are deep, narrow slot canyons—southeast of the Paunsaugunt Plateau and southwest of the Kaiparowits Plateau. Uplift of the Colorado Plateau and earlier compression that created broad regional folds left their mark on the region's rock as sets of aligned fractures. Fractures offer pathways for moving water, which deepens them, forming slot canyons. Many of these canyons are 100 feet deep but only 5 or 10 feet across. Runoff from rainstorms high on the plateaus or on impermeable sandstone benches gets funneled into these narrow canyons, creating dangerous flash floods.

Fracture in Navajo Sandstone in Buckskin Gulch in the Paria River basin

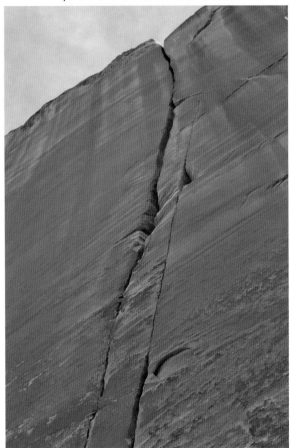

Slot canyon in the Paria River basin

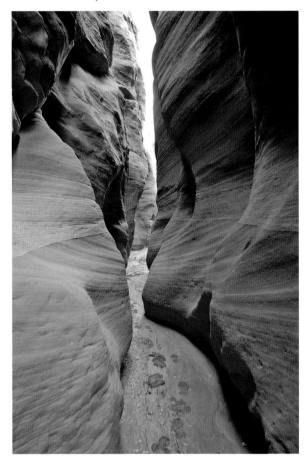

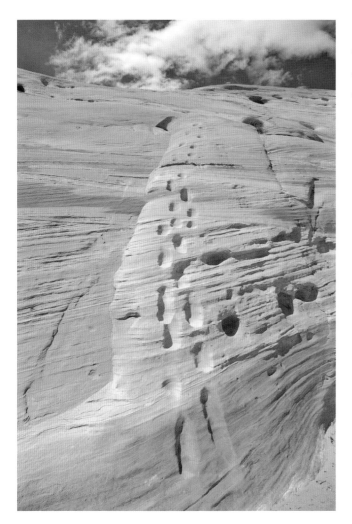

Ancient ladder carved by Native Americans into crossbedded Page Sandstone in the Paria River basin

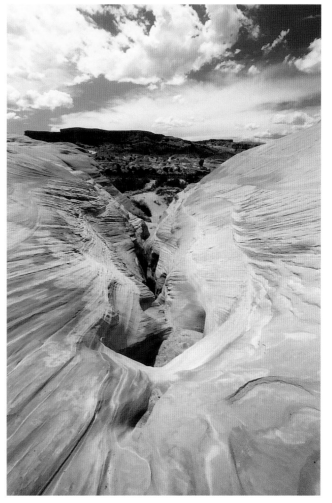

A slot canyon develops in Page Sandstone in the Paria River basin

Surface Staining

As water moves through pores and fractures in rock, it dissolves minerals. When it flows back onto the surface at a seep or spring, some of those minerals precipitate and change the colors of the rock. Iron oxides, for example, will stain rock faces (or bathtubs) red. Some black stains are microbial mats; these form where water regularly flows over the same part of a rock. You can see them on cliff faces where water has obviously spilled over the lip during rainstorms.

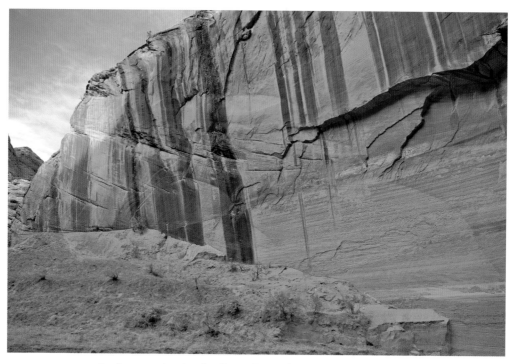

Surface stains in the Paria River basin associated with overflowing water and organic activity

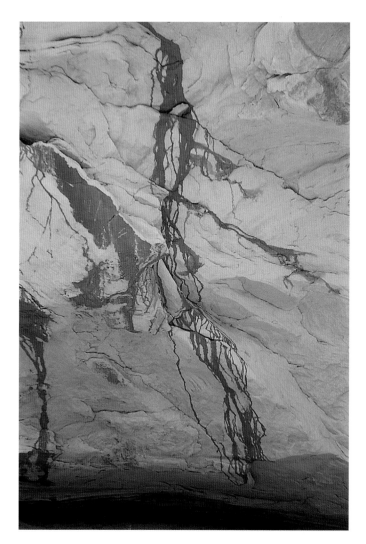

Iron-stained sandstone

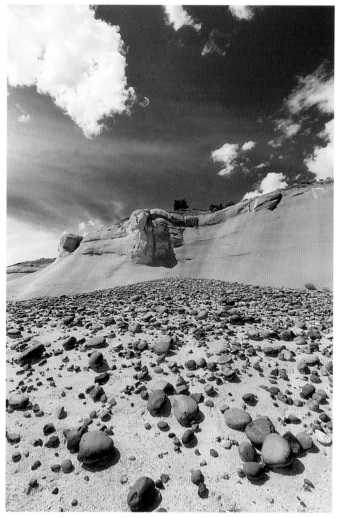

Whitehouse, eroded in Page Sandstone
in the Paria River basin, with old
river gravels in the foreground

Slope Formers and Mushroom Rocks

Shale, mudstone, and siltstone are less resistant to erosion than is well-cemented sandstone. Whereas sandstone tends to form steep cliff faces in the arid southwestern United States, shale, mudstone, and siltstone form shallow slopes. These less resistant rocks, called "slope formers" by geologists, are often covered with networks of tiny channels that attest to the ease with which moving water carries away particles. Sometimes sandstones are poorly cemented and erode easily too.

Mushroom rocks in the Paria Rimrocks on the southern edge of the Kaiparowits Plateau feature resistant caprocks that overlie and protect weak, easily eroded pedestals of siltstone, mudstone, or even poorly cemented sandstone. Eventually the pedestal will thin to the point where the caprock tumbles to the ground. Without its protective cap, the pedestal will quickly erode to nothing.

Mushroom rocks of the weak Carmel Formation capped by sturdy Dakota Sandstone in the Paria River basin

Easily eroded, slope-forming siltstone, mudstone, and poorly cemented sandstone of the Carmel (red) *and Entrada* (white) *Formations in the Paria River basin*

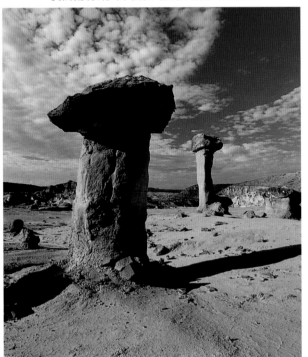

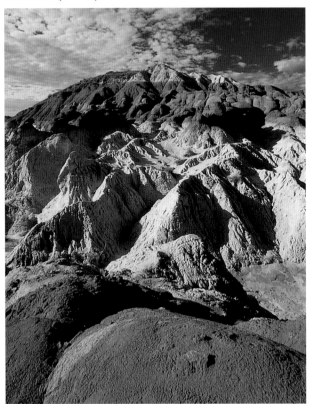

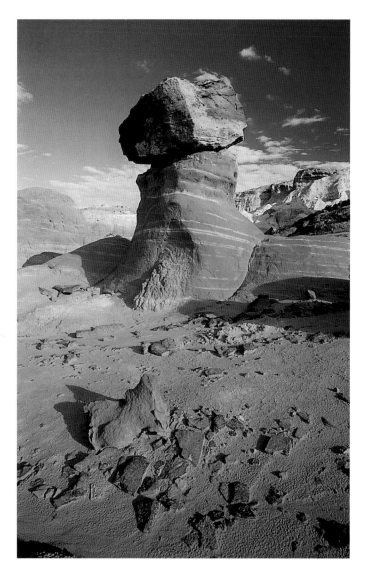

Mushroom rock in the Paria River basin

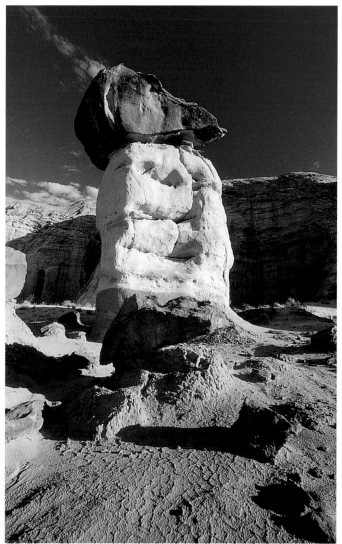

*Mushroom rock in the Paria River
basin of intertonguing Entrada (white)
and Carmel (red) Formations*

Lake Powell

Construction of the Glen Canyon Dam in Page, Arizona, began in 1959 and ended with its dedication ceremony in 1966. After completion, the gates were shut and Colorado River water began to fill the reservoir. It took seventeen years for Lake Powell to hit its high-water mark. The dam is in Arizona, but the 186-mile-long lake is mostly in southern Utah. Lake Powell has 1,900 miles of shoreline with over ninety major tributary canyons. The central portion rests in Glen Canyon, a deep chasm that was said to rival the beauty of the Grand Canyon prior to infilling. Navajo Mountain, a Tertiary-age igneous intrusion still draped with rocks of Jurassic age, lies south of the lake in Utah. Lake Powell is most certainly not a geologic landform, but its blue waters provide a stunning contrast to the red sandstones of many different formations that reflect from its placid surface.

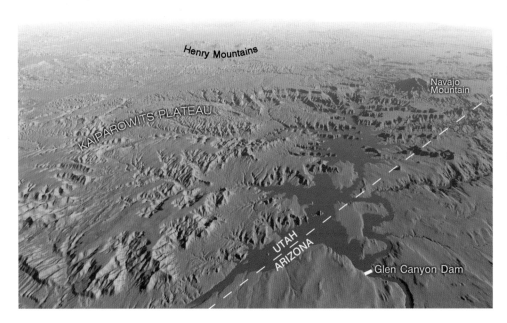

Low-angle shaded-relief view to the northeast of Lake Powell

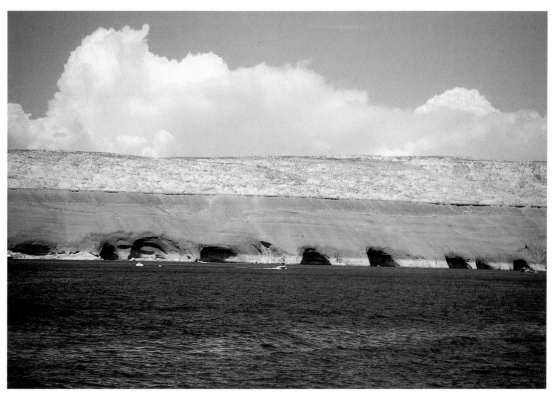

*White high-water mark accentuating a row of alcoves weathered
into red Navajo Sandstone prior to inundation by Lake Powell*

Fish Lake

Fish Lake, at an elevation of 8,405 feet, sits in a northeast-trending graben, a narrow, down-dropped block between two parallel faults. About 10,000 years ago, movement along one or both of the bounding faults shifted drainage from the lake to the north, leaving behind an abandoned waterfall and stream channel in the south. The highlands surrounding the lake bear evidence of past glaciation. Ice carved broad U-shaped valleys and deposited sediment into large debris mounds, called *moraines*, during the ice ages that occurred during Pleistocene time, from 1.8 million years ago to 10,000 years ago. High-relief, well-formed moraines date to the last glacial stage, about 20,000 years ago, while more subdued mounds date to earlier episodes of glaciation.

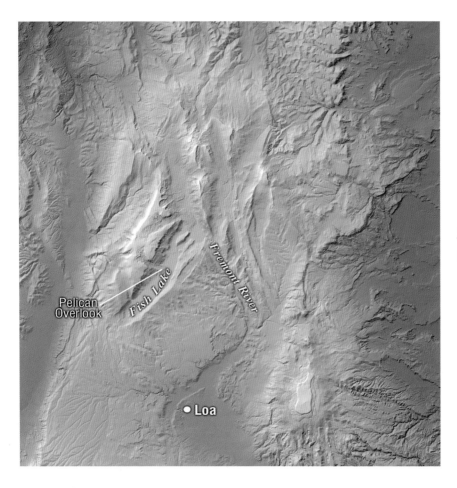

Shaded-relief map of Fish Lake

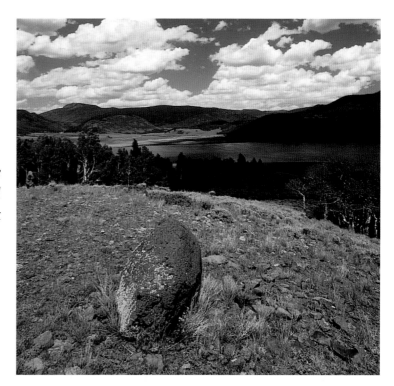

View to the east at Fish Lake from the bouldery glacial moraine at Pelican Overlook

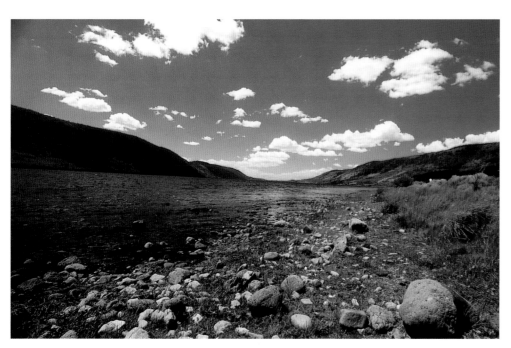

View to the south at Fish Lake, in a down-dropped fault block

Capitol Reef National Park

Early settlers called steeply tilted rock layers that blocked their passage west "reefs." Angled layers of rock within the Waterpocket Fold form Capitol Reef in Capitol Reef National Park. Regional compression lifted rock deep below the surface on the west side of the fold by as much as 7,000 feet, bending overlying sedimentary rock layers into a 100-mile-long fold called a *monocline*. The Fremont River then cut down into the bent rock layers, revealing the inner structure of the fold. Flat-lying strata just east of the monocline form North Caineville Mesa, South Caineville Mesa, and Factory Butte at the east entrance to the park. In the mesas, resistant Mesaverde Sandstone caps the weak and easily eroded gray Mancos Shale.

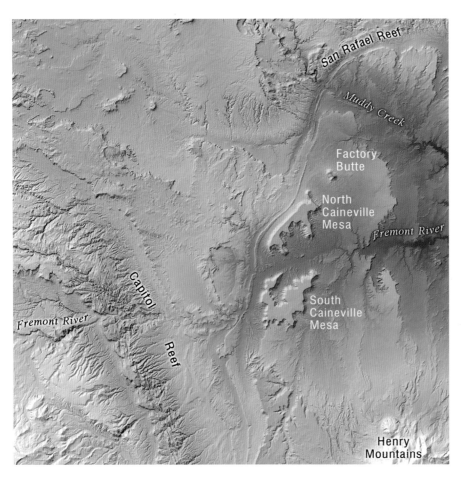

Shaded-relief map of Capitol Reef National Park and vicinity

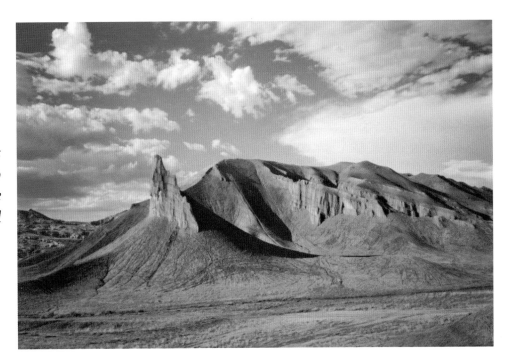

Layers of Mancos Shale sloping down to the east (right) in the Waterpocket Fold

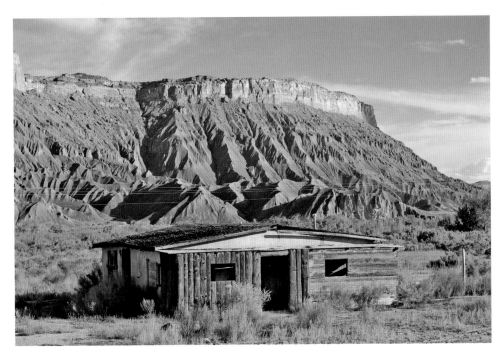

Flat layers of Mesaverde Sandstone form cliffs at the top of South Caineville Mesa, with eroding Mancos Shale below

Henry Mountains

John Wesley Powell, a one-armed Civil War veteran and the first explorer to negotiate the Colorado River through the Grand Canyon, named the Henry Mountains for Joseph Henry, first secretary of the Smithsonian Institution. The Henry Mountains are a laccolith, a mushroom-shaped hunk of igneous rock. Starting about 30 million years ago, magma intruded into sedimentary rock and forced the layers to dome upward. It then cooled and crystallized into an igneous rock called *diorite*. Erosion later removed the overlying sedimentary rock and exposed the more resistant diorite.

Mount Ellen, at 11,522 feet, is the highest peak in the Henry Mountains. The two somewhat isolated, smaller peaks to the south are called the Little Rockies and are also part of the intrusive body.

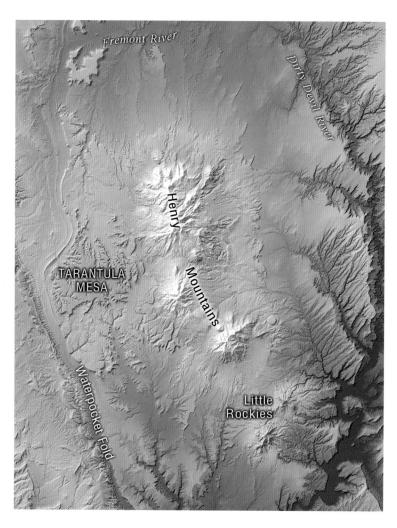

Shaded-relief map of the Henry Mountains

The Henry Mountains, formed by an igneous intrusion that domed up sedimentary rock, which is visible at the base of the mountains

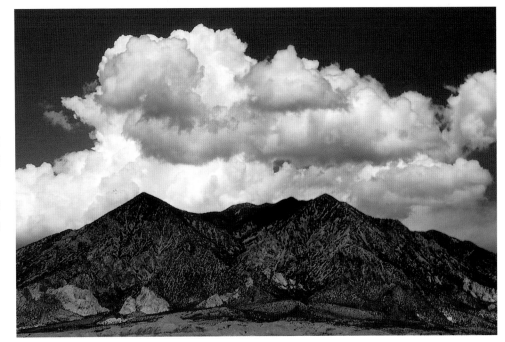

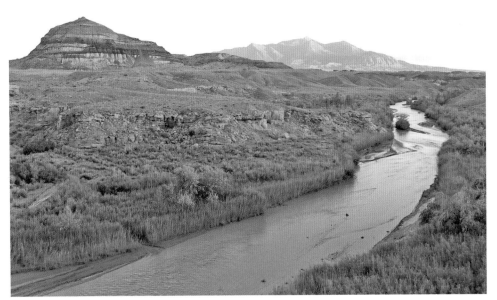

View to the south with the Fremont River in the foreground and the Henry Mountains in the distance

San Rafael Swell

The San Rafael Swell is a kidney-shaped anticline, an upward fold of rock, that rises 2,000 feet above the surrounding landscape. The San Rafael Reef is the name given to its steeply dipping eastern flank. Regional compression that built the modern Rocky Mountains 60 million years ago caused deep, underlying rock of Precambrian age to fracture and move upward. Layers of much younger sedimentary rock were pushed into a fold over the rising core of crystalline rock, similar to how layers of cloth would drape over a block of wood moved up from below. Erosion in the north by the San Rafael River and in the south by tributaries of the Dirty Devil River have revealed older rock at the center of the fold and younger rock at the margins.

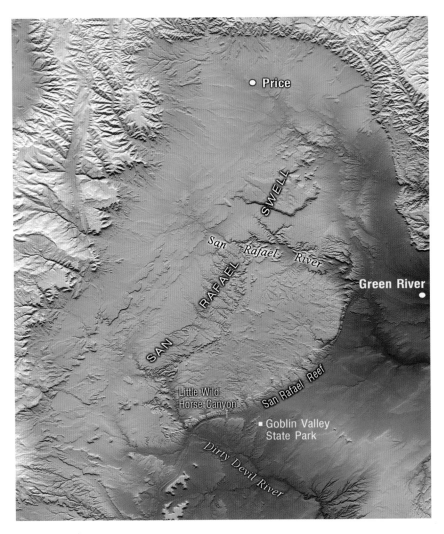

Shaded-relief map of the San Rafael Swell

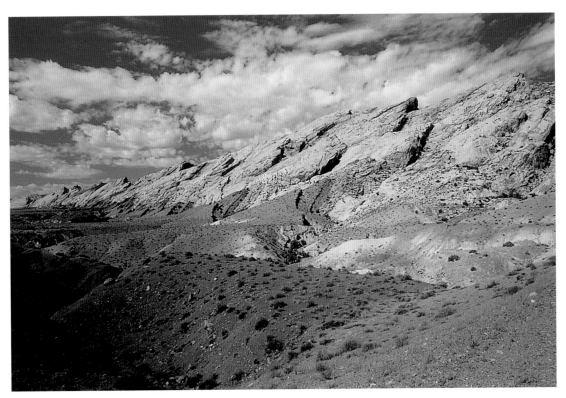

View to the south along the San Rafael Reef

Little Wild Horse Canyon

As the San Rafael Swell rose, the rock cracked, and many fractures extended across the San Rafael Reef. Much of the water that fell as rain in the uplifted center of the fold flowed east across the reef, finding easier passage in the fractures and carving deep, narrow canyons like Little Wild Horse Canyon, north of Hanksville. These slot canyons are dry most of the year, but rain can cause flash floods that fill them suddenly to depths of tens of feet. The rapidly moving water has polished canyon walls and floors and formed pools and waterfalls, which can make hiking very difficult.

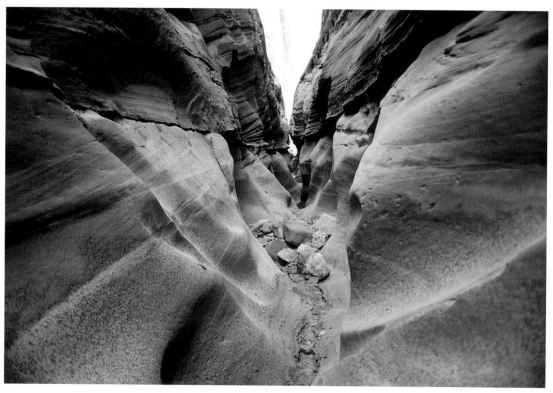

Polished walls of Little Wild Horse Canyon

Trail in Little Wild Horse Canyon

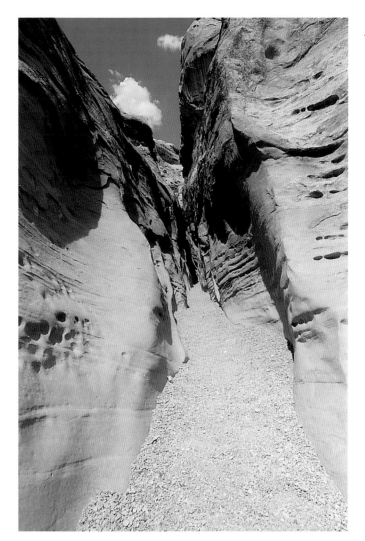

Pools in Little Wild Horse Canyon accentuating sedimentary rock layers that dip steeply away from the San Rafael Swell

Goblin Valley State Park

Weathering and erosion have produced mushroom rocks in the Entrada Sandstone of Jurassic age in Goblin Valley State Park, just southeast of the San Rafael Reef. The Entrada Sandstone is composed of interbedded layers of shale, siltstone, and sandstone that were deposited in an ancient tidal mudflat cut by stream channels. Regional uplift and faulting produced many fractures in the Entrada Sandstone. As the fractured rock weathers and erodes, the more resistant sandstone layers act as caprocks that protect more delicate layers of shale and siltstone. When the sandstone layers are completely removed, the siltstone and shale erode away rapidly. Runoff from rain has created intricate networks of small channels that cover the surfaces of the weak rock. The diversity of rock types and cementation within the Entrada Sandstone is reflected in the diversity of forms that goblins take.

A mushroom rock at Goblin Valley State Park

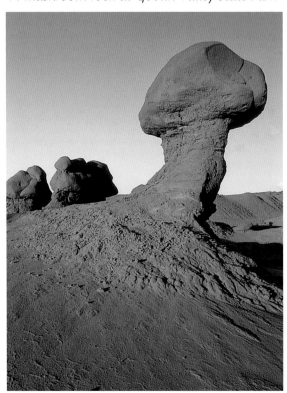

The goblin life cycle, from the valley wall of layered Entrada Sandstone to a goblin with a rapidly eroding pedastal

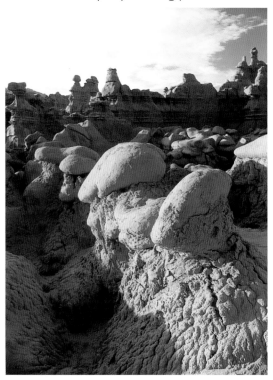

Goblins silhouetted against the sunset at Goblin Valley State Park

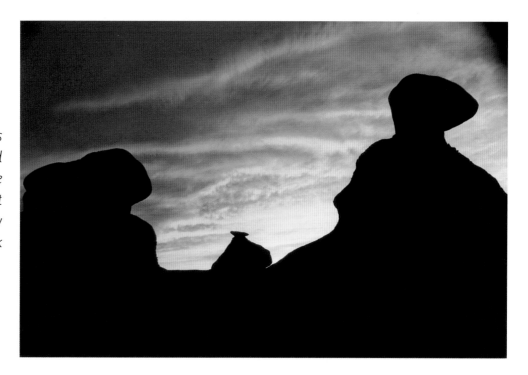

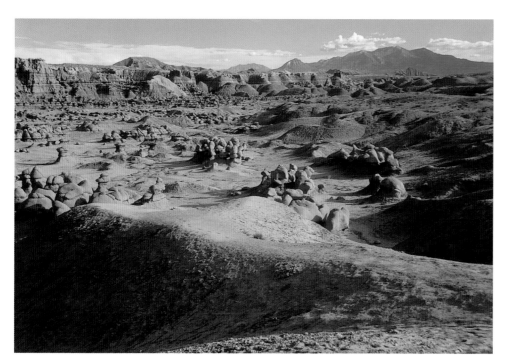

View to the south across Goblin Valley with bluish Curtis Formation and the Henry Mountains in the distance

Canyonlands National Park

The Green River begins in Wyoming's Wind River Range and flows south, joining the Colorado River, which flows west out of the Rockies of Colorado, in the Needles District of Canyonlands National Park. Prior to 6 million years ago, the Colorado and Green Rivers probably flowed northeast in meandering channels across a flat plain. Uplift of the Colorado Plateau forced these two rivers and their tributaries to erode downward, carving sinuous canyons known to geologists as *entrenched meanders*. Dead Horse Point State Park on Island in the Sky offers great views of the meandering Colorado River, and Grand View Point looks over the Green River.

The White Rim Sandstone of Permian age forms a white bench above the river canyons that can be seen from many lookouts on Island in the Sky. Percolating water likely removed the red iron oxide cement from the sandstone. Although it is highly fractured, the White Rim Sandstone protects the weaker Organ Rock Shale below it from erosion.

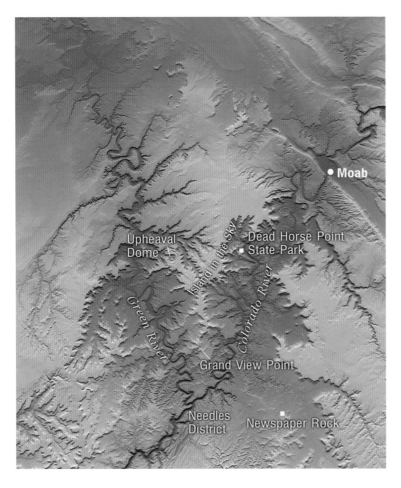

Shaded-relief map of Canyonlands National Park

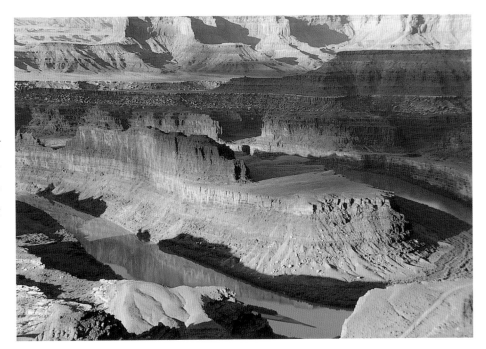

Horseshoe Bend of the Colorado River from Dead Horse Point State Park

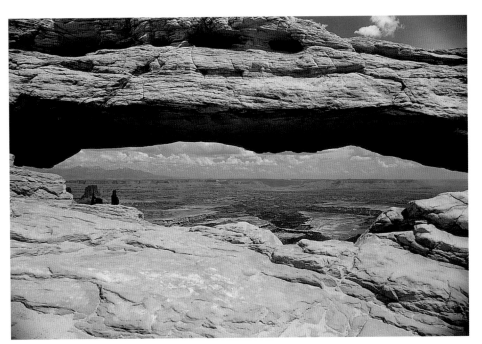

White Rim Sandstone visible in the distance through Mesa Arch at Island in the Sky

Upheaval Dome

Upheaval Dome is an enigmatic circular structure on Island in the Sky in Canyonlands National Park. This 3.4-mile-wide dome of Kayenta Formation and Navajo Sandstone of Jurassic age contains nearly vertical beds of White Rim Sandstone in the center. Geologists have hypothesized that the structure may have been formed by the upward movement of a mass of salt like those that have domed rock and trapped oil and gas in the Gulf Coast region. A more likely hypothesis—though the discussion is far from over—is that Upheaval Dome formed deep below the surface when a meteorite struck rock layers at the surface. Erosion removed the upper rock layers and eventually exposed the structure we see today.

Folded rock layers in Upheaval Dome

Center of Upheaval Dome, with vertical beds of light-colored White Rim Sandstone in the middle

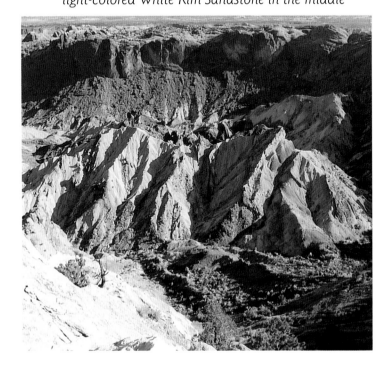

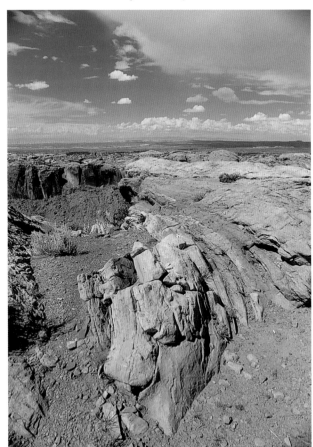

Newspaper Rock

Newspaper Rock, along State Route 211 east of Canyonlands National Park, offers a glimpse at the artistry of southern Utah's early inhabitants. Ancient artists carved petroglyphs into a dark patina called *rock varnish*. In arid and semiarid regions, microbial communities extract manganese from the atmosphere and excrete a sticky film of black manganese oxide on the rock face. Wind-blown clay and other debris adheres to the sticky oxide, thickening the coating. Rock varnish often has a sheen produced by wind abrasion.

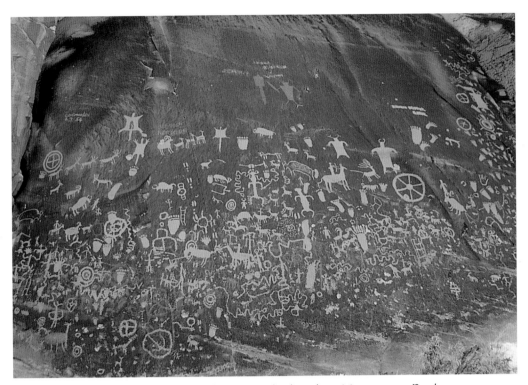

Petroglyphs carved in varnished rock at Newspaper Rock

Arches National Park

About 300 million years ago, southeastern Utah was part of the Paradox Sea, a body of water that was periodically connected to the world's oceans and then cut off from them by changes in water level and topography. The climate was warm enough to completely evaporate the sea when it was isolated from other water bodies, and salt precipitated on the dry seabed. Over millions of years, the salt reached a thickness of 6,000 feet. The Ancestral Rocky Mountains rose about 275 million years ago, and the salt flowed and thickened under the stress, creating arched folds in the overlying rock with salt cores more than 10,000 feet thick. As the Colorado Plateau rose 6 million years ago, the Colorado River and its tributaries eroded channels into the rocks, and rainwater infiltrated and dissolved the salt about 2 million years ago. The dissolving anticlines left cavities, which then collapsed into roughly parallel valleys, including the Salt, Cache, Castle, and Spanish Valleys in and around Arches National Park.

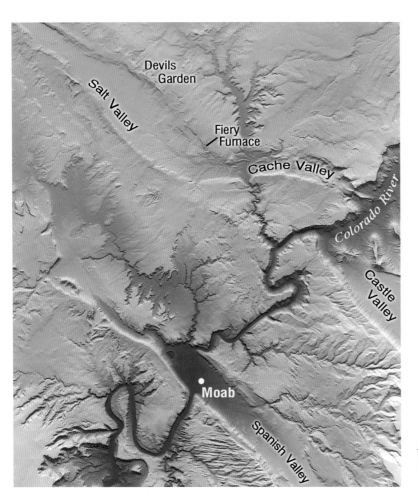

Shaded-relief map of parallel valleys near Arches National Park

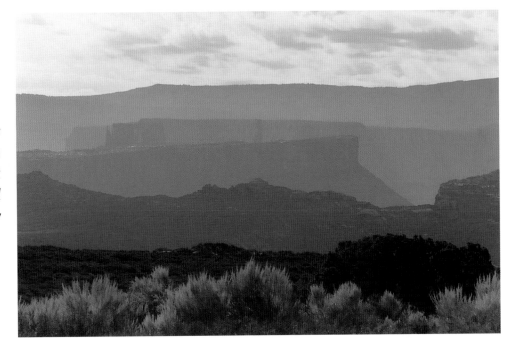

*View to the
southeast from
the rim of Salt
Valley toward
Castle Valley*

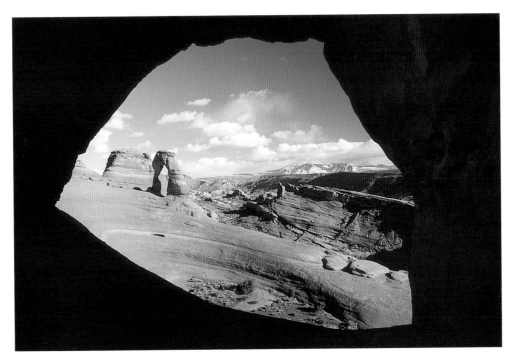

*View to the southeast
through the Eye at
Delicate Arch with
the La Sal Mountains
in the distance*

Castle Valley

Castle Valley is one of several valleys created by the dissolution and collapse of salt-cored folds. The southwest-dipping sedimentary rock layers along Porcupine Rim at the western edge of Castle Valley are part of the original fold. Sandstone on the eastern edge of Castle Valley has weathered and eroded into less consistent but equally interesting landforms including Castle Rock and the Priest and Nuns. Round Mountain is an igneous intrusion probably connected at depth to the La Sal Mountains, which are also igneous. The presence of sandstone on the top of Round Mountain indicates that the magma solidified at depth and did not reach the surface.

Round Mountain obscured by smoke from a forest fire

Round Mountain in Castle Valley

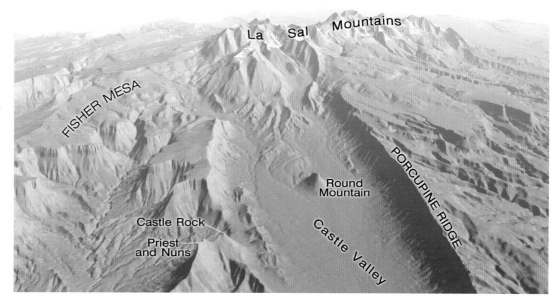

Low-angle shaded-relief view to the south of Castle Valley

La Sal Mountains

FISHER MESA

PORCUPINE RIDGE

Round Mountain

Castle Rock

Priest and Nuns

Castle Valley

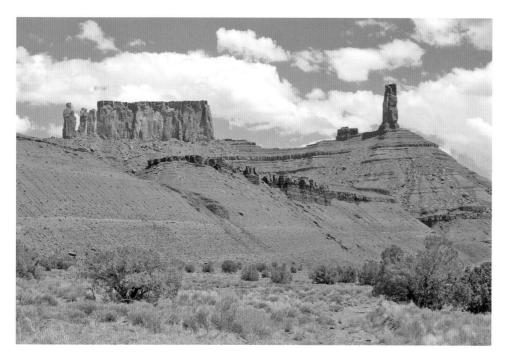

Priest and Nuns (left) and Castle Rock (right) in Castle Valley

Fins

The folded, brittle rock fractured as it settled into valleys after the salt dissolved about 2 million years ago. In general, those fractures parallel the valleys. Weathering and erosion widened the fractures and eventually created stands of aligned rock ridges, also parallel to valleys, that geologists call *fins*. Devils Garden and Fiery Furnace contain abundant examples of fins in Entrada Sandstone that formed parallel to Salt Valley along its northeastern edge. Erosion has broadened gaps between fins at Devils Garden, while fins at the Fiery Furnace are separated only by tight passageways.

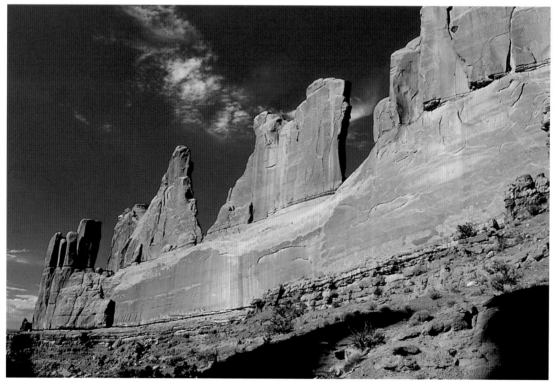

Park Avenue, a fin of Entrada Sandstone, in Arches National Park

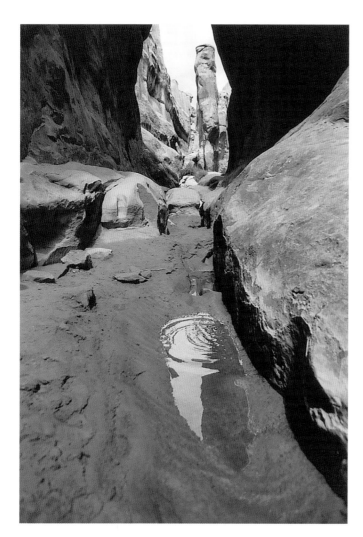

*Tight passageway
between fins in the
Fiery Furnace*

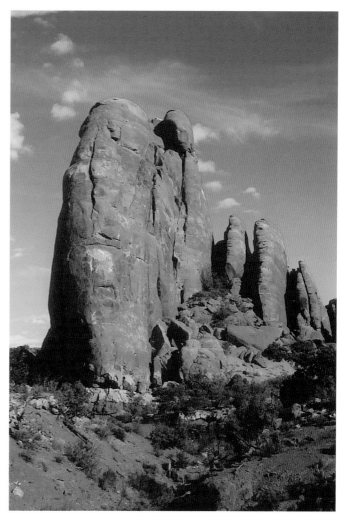

*Parallel fins of
Entrada Sandstone
at Devils Garden*

Arches

In Arches National Park, many fins have weathered into freestanding arches. Most arches in the park occur in the Entrada Sandstone, which was deposited in Jurassic time in tidal mudflats cut by sandy stream channels. The Entrada is composed of resistant rock layers with zones of weakness between them. Weathering occurs rapidly within zones of weakness, creating hollows called *alcoves*. An arch forms when the erosive agents penetrate entirely through a narrow fin. Arches National Park has more than two thousand arches in an incredible variety of sizes and shapes.

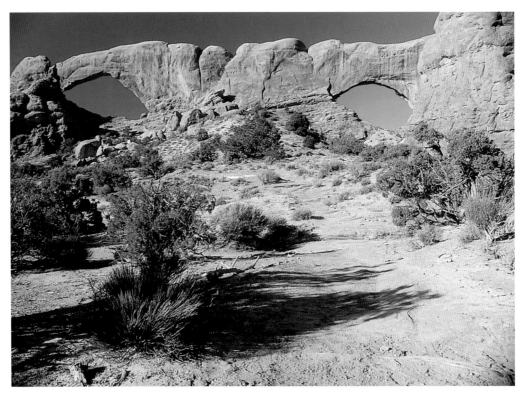

The Windows in Arches National Park

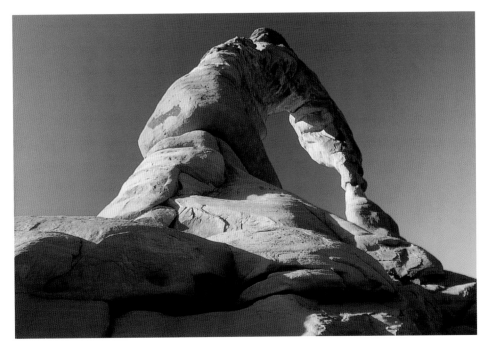

Delicate Arch in Arches National Park

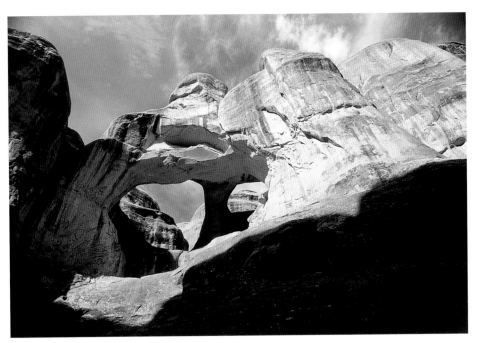

An arch at Fiery Furnace in Arches National Park

Rockfalls

Wherever there are high cliff faces—and that pretty much describes all of southern Utah—gravity always exerts its influence. In southern Utah, fractured rock often gives way and tumbles to the base of cliffs. Heavy rain or snowmelt lubricates fractures or bedding planes, triggering major rockfalls and slides. Earthquakes also reduce frictional resistance and precipitate failure.

In the winter, water percolates into fractures in the day when rock surfaces warm above freezing and then crystallizes into ice at night, expanding in volume and enlarging fractures. In the morning, the ice melts and rock falls. This process, called *frost wedging*, is one of many weathering processes that aid the work of gravity.

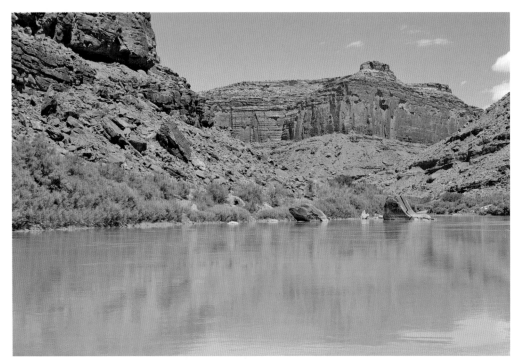

Rockfall in the Colorado River

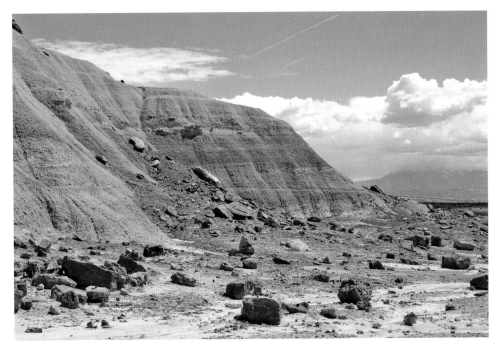

Angular chunks of sandstone littering the ground after sliding down from above over weathered and eroded shale of the Morrison Formation

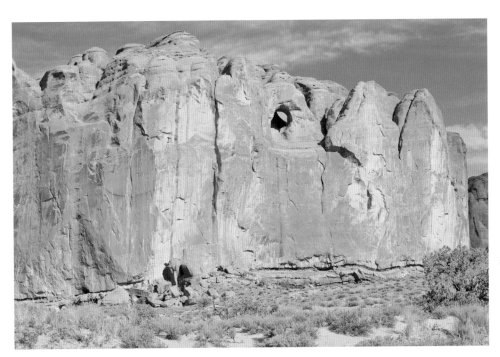

The small arch will fall someday, becoming a pile of rocks at the cliff base

La Sal Mountains

About 25 million years ago, magma intruded between sedimentary rock layers beneath the earth's surface, doming the overlying rock upward. When it cooled, it was a mushroom-shaped igneous mass called a *laccolith*. The domed sedimentary rock layers eroded away, leaving behind the stronger igneous rock of the La Sal Mountains. The mountains are superimposed on Castle, Paradox, and Spanish Valleys, which were once parallel folds cored by salt. The presence of salt cores—which dissolved much later—may have created weak zones that aided the upward movement of magma.

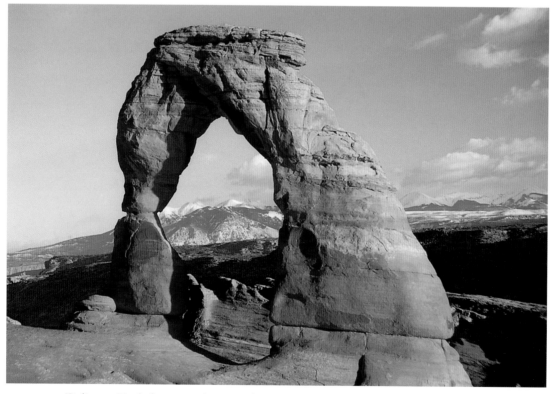

Delicate Arch framing the La Sal Mountains in the distance to the south

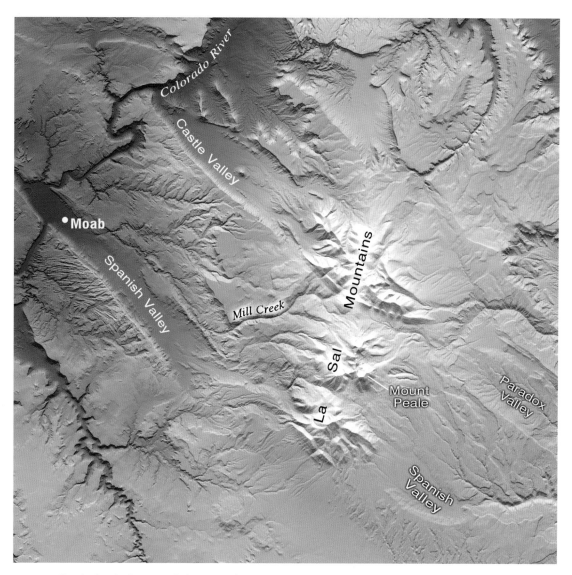

Shaded-relief map of the La Sal Mountains superimposed on collapsed valleys

Glaciers in the Mountains

Below the high peaks of the La Sal Mountains, glaciers carved broad U-shaped valleys during the last glacial stage, which peaked about 20,000 years ago. When the glaciers melted, they left behind a land surface covered by boulders, small lakes, and high cirques, amphitheater-like depressions carved into the mountain face. Sediment deposited directly by the glacial ice formed mounds called *moraines*. End moraines form at the glacier's snout, and lateral moraines form at the glacier's sides. While the peaks, including Mount Peale at 12,721 feet, were not covered by ice, freeze-and-thaw cycles have reduced the crystalline bedrock there to angular rubble.

Alpine tundra and fractured bedrock in the La Sal Mountains

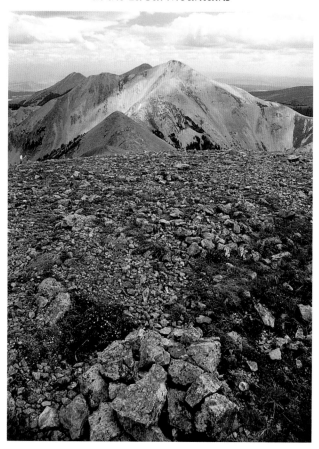

Glacial debris in the foreground with Mount Peale in the distance towering above a glacially carved valley

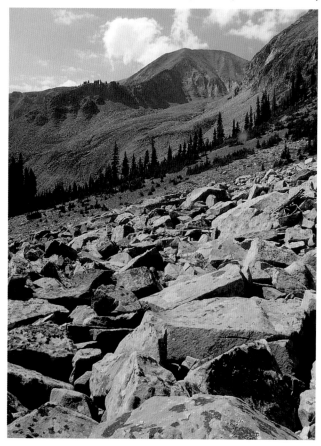

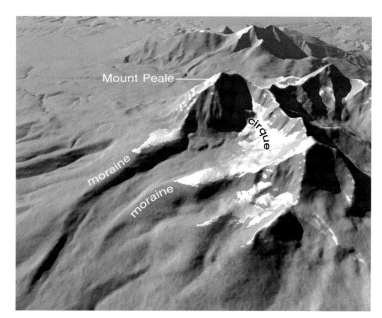

Low-angle shaded-relief view to the southwest of Mount Peale with glacially carved valley and lateral moraines extending to the east (bottom left)

Mount Peale

cirque

moraine

moraine

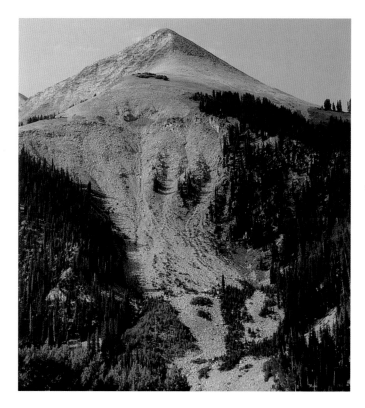

Avalanche chute near treeline in the La Sal Mountains

Monument Valley and Valley of the Gods

The Monument Uplift of southern Utah and northern Arizona is a broad, northeast-trending fold that was bowed upward by regional compression beginning about 60 million years ago. In the large central region of the Monument Uplift, sedimentary rock layers are roughly horizontal and form flat-topped mesas, broader than they are tall; buttes, taller than they are broad; and monoliths, very narrow spires with not much of a future, geologically speaking. In Monument Valley in the southern part of the uplift, mesas, buttes, and monoliths are constructed of resistant De Chelly Sandstone on broad, shallow slopes of weak Organ Rock Shale, both of Permian age. Some landforms feature layers of Moenkopi Formation and Chinle Formation of Triassic age on top of the De Chelly Sandstone. In Valley of the Gods, in the northern part of the uplift, resistant Cedar Mesa Sandstone forms mesas, buttes, and monoliths over weak Halgaito Shale, both of Permian age.

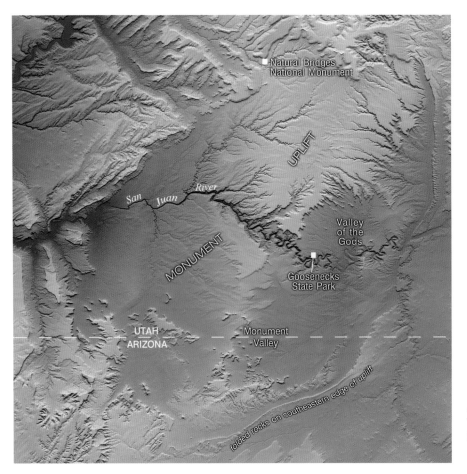

Shaded-relief map of the Monument Uplift

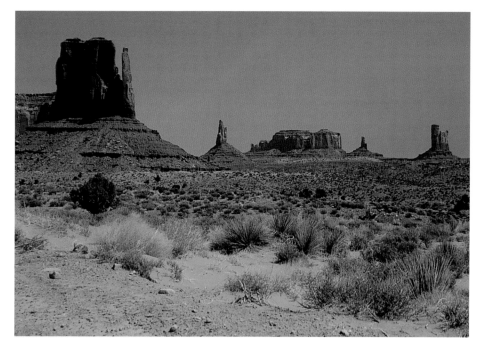

View to the northwest of (from left) West Mitten, Big Chief, Saddleback, Castle Rock, and Stagecoach in Monument Valley

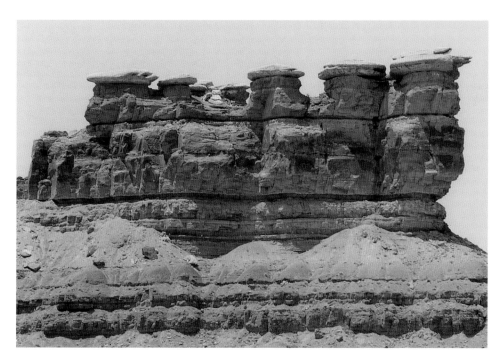

Cedar Mesa Sandstone capping Halgaito Shale in Valley of the Gods

Goosenecks State Park

The San Juan River, a tributary of the Colorado River, flows west across the center of the Monument Uplift. As the Colorado Plateau rose during the last 6 million years, the San Juan River cut downward through layers of rock, deepening its preexisting meanders into the canyons we see today, which geologists call *incised meanders*. The overlook at Goosenecks State Park offers dramatic views of the sinuous incised meanders. Alhambra Rock, which protrudes above the flat-lying strata incised by the river, looks similar from a distance to the buttes at nearby Valley of the Gods, but it is an igneous dike. Magma rose through a fracture in the sedimentary rock about 30 million years ago and crystallized into a resistant igneous rock.

Rainbow on Alhambra Rock, an igneous dike

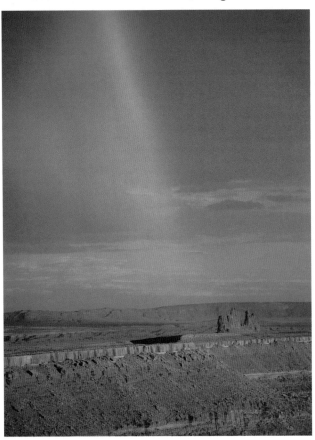

View to the south of the sinuous curves in the San Juan River at Goosenecks State Park with Alhambra Rock on the horizon (far left)

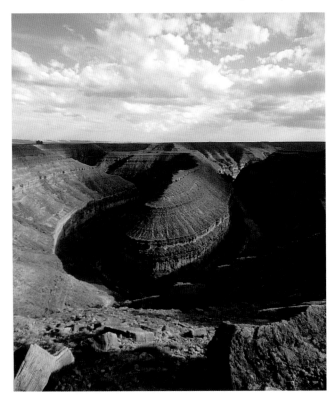

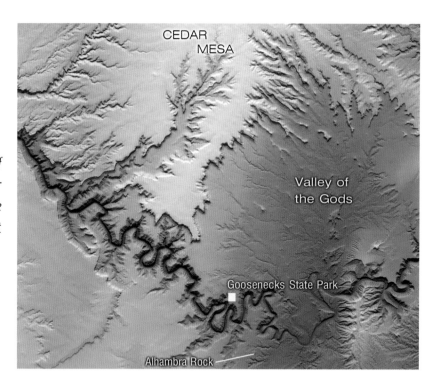

Shaded-relief map of the San Juan River cutting through the Monument Uplift

CEDAR MESA

Valley of the Gods

Goosenecks State Park

Alhambra Rock

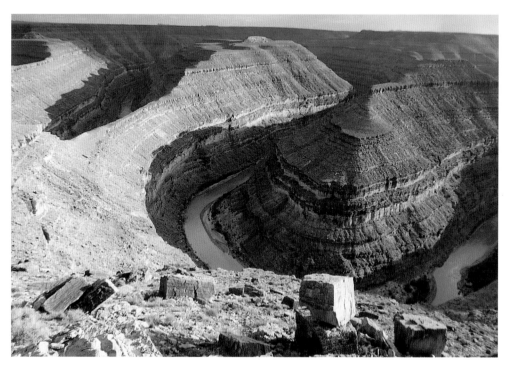

View to the south of the meanders in the San Juan River at Goosenecks State Park

Natural Bridges National Monument

Cedar Mesa makes up the northern part of the Monument Uplift. Cedar Mesa Sandstone was deposited in Permian time in sand dunes and beaches. After the Colorado Plateau began rising 6 million years ago, water carved Armstrong, White, and Tuwa Canyons in Natural Bridges National Monument. Over time, the streams undercut the resistant rock walls of Cedar Mesa Sandstone, forming natural bridges. Young spans like Kachina Bridge are broad, thick structures relative to the gap beneath them. Weathering and gravity cause rock to fracture and fall from the base of a bridge, thinning it with age. Old bridges like Owachomo Bridge are skinny, frail spans over large gaps. Sipapu Bridge is intermediate in size, so geologists hypothesize it is intermediate in age as well.

Kachina Bridge in Cedar Mesa Sandstone at Natural Bridges National Monument

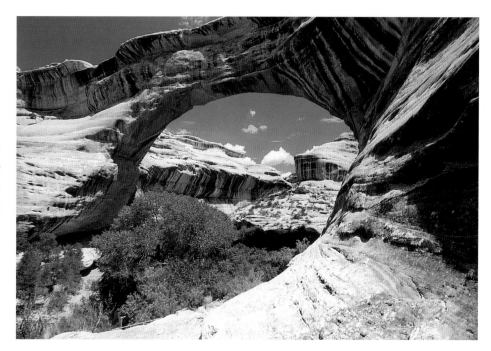

Sipapu Bridge in Cedar Mesa Sandstone at Natural Bridges National Monument

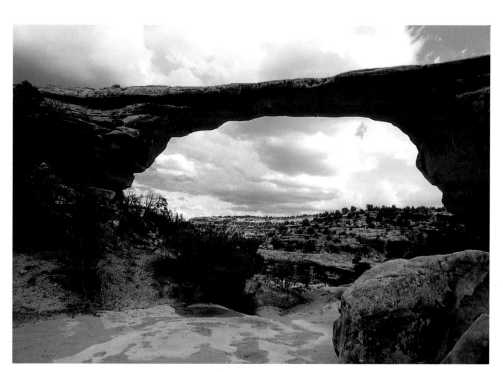

Owachomo Bridge in Cedar Mesa Sandstone at Natural Bridges National Monument

Glossary

anticline. An up-arching fold of rock layers.

ash. Fine-grained volcanic glass erupted into the atmosphere.

basalt. A fine-grained, dark igneous rock that cooled from lava extruded on the surface of earth. It contains the minerals plagioclase feldspar, pyroxene, and olivine and often has vesicles formed from the expansion of gases as the lava cooled.

Basin and Range. A physiographic province within the western United States with north-south-trending, fault-bound mountain ranges and desert valleys. This region has experienced broad doming and crustal thinning.

bedrock. Solid rock, either exposed at the surface or lying beneath a mantle of unconsolidated material.

beds, bedding. The layered structure of sedimentary rocks.

butte. A steeply sided, flat-topped, isolated hill.

carbonate rock. A family of rock that includes limestone, dolomite, and marble. Caves form in carbonate rock by dissolution.

cement. Mineral material that binds sedimentary rock grains together. Most common cements are silicas, carbonates, and iron oxides.

chemical weathering. The chemical alteration of rock at or near the earth's surface.

cinder. Coarse, angular particle of hardened lava.

cinder cone. A conical accumulation of cinders, or gravel-sized pieces of basalt.

cirque. A bowl-shaped, glacially carved depression at the head of a mountain valley.

conglomerate. A sedimentary rock composed of rounded pebbles and gravel eroded from preexisting rock.

crossbeds, crossbedding. Inclined sedimentary layers that indicate changes in wind or water direction during deposition.

crust (earth). The outermost shell of the earth, ranging in thickness from 10 to 50 kilometers, depending on whether it is oceanic or continental.

dike. A tabular intrusion of igneous rock that cuts across the rock into which it has intruded.

downwarp. A downward bend in the earth's crust.

erosion. The removal and transportation of rock and sediment by water, wind, and ice.

escarpment. Abrubt, steep slope usually due to a fault offset or mass wasting.

fault. A fracture in rock along which the rock on one side has moved relative to the rock on the other side.

folds. Symmetrical or asymmetrical bends in rock layers.

formation. A mappable and distinct rock unit deposited under a uniform set of conditions.

glacier. A large mass of flowing ice.

hoodoos. Prominent spires that form from rapid erosion of a weak substrate.

igneous rock. Rock formed from the cooling and crystallization of magma.

intrusive rock. A rock body that forms from magma and cools beneath the earth's surface.

iron oxide. A compound of iron and oxygen, such as ferric oxide, which occurs naturally as rust.

joint. A fracture in a rock with no displacement or relative movement.

laccolith. A large, mushroom-shaped, intrusive igneous rock.

lava. Molten rock material on the earth's surface.

lava flows. The spread of lava once it reaches the surface. Types of lava flows include pahoehoe, aa, and pillow.

limestone. A sedimentary rock mainly composed of the mineral calcite, a calcium carbonate.

magma. Molten rock beneath the earth's surface.

mesa. A large flat-topped landform with steep sloping sides.

moraine. An accumulation of clay, sand, gravel, cobbles, and boulders deposited by a glacier.

mudstone. A sedimentary rock with approximately equal proportions of clay and silt with layers several feet thick.

ore. An economically viable mineral deposit commonly containing such minerals as gold, silver, and copper.

petroglyph. A drawing chipped or carved into a rock surface.

playa. An unvegetated, flat, salty surface that remains after a lake has evaporated.

sandstone. Sedimentary rock made of sand-sized fragments of preexisting rock, commonly held together by silica, clay, iron oxide, or calcium carbonate cement.

sedimentary rock. Rock made of the weathered remains of preexisting rock.

shale. A sedimentary rock consisting mainly of clay minerals, the laminate structure of which causes it to break along parallel planes.

siltstone. A sedimentary rock made of grains intermediate in size between clay (smaller) and sand (larger). Silt refers to microscopic particles that the rock is composed of.

syncline. A downward-bending fold in rock layers. The convex part points down.

tectonic. Pertaining to forces involved in the deformation of the earth's crust.

tectonic plate. A defined area of the earth's crust that moves relative to other crustal areas. There are seven large plates and many smaller ones that make up the earth's crust.

terrace. A relatively flat surface breaking the continuity of a slope.

tuff. A general term used to describe rocks formed of consolidated fragments of volcanic ash.

upwarp. An upward arching of sediment layers.

varnish, rock. A patina of iron, manganese, and clay that builds up on rock surfaces exposed for a long time in an arid environment.

water gap. A stream-cut valley that crosses a ridge.

wave-cut terrace. Flat surface created by wave erosion.

weathering. The physical disintegration and chemical decomposition of rocks at the earth's surface.

Recommended Reading

Abbey, Edward. 1968. *Desert Solitaire: A Season in the Wilderness*. New York: Simon and Schuster.

Baars, Donald L. 1981. *The Colorado Plateau: A Geologic History*. Albuquerque: University of New Mexico Press.

Baldridge, W. Scott. 2004. *Geology of the American Southwest: A Journey through Two Billion Years of Plate-Tectonic History*. Cambridge University Press.

Chronic, Halka. 1990. *Roadside Geology of Utah*. Missoula, Montana: Mountain Press Publishing Company.

Fillmore, Robert. 2000. *Geology of Parks, Monuments, and Wildlands of Southern Utah*. Salt Lake City: University of Utah Press.

Orndorff, Richard L., Robert W. Wieder, and David G. Futey. 2006. *Geology Underfoot in Southern Utah*. Missoula, Montana: Mountain Press Publishing Company.

Sprinkel, Douglas A., Thomas C. Chidsey, Jr., and Paul B. Anderson, editors. 2000. *Geology of Utah's Parks and Monuments*. Salt Lake City: Utah Geological Association Publication 28.

Stokes, William Lee. 1986. *Geology of Utah*. Salt Lake City: Utah Museum of Natural History, University of Utah.

Index

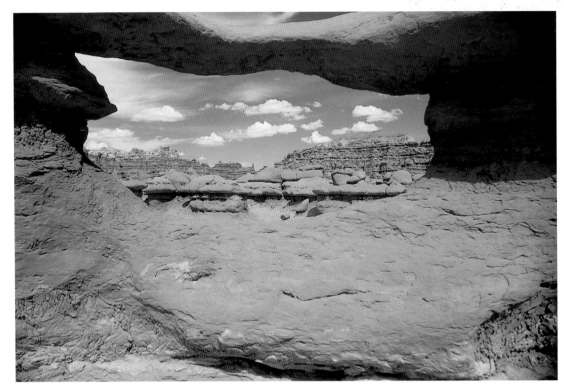

Goblin Valley State Park

About the Authors

Richard L. Orndorff, a faculty member in the Department of Geology at Eastern Washington University, is a coauthor of *Geology Underfoot in Central Nevada* and *Geology Underfoot in Southern Utah*, published by Mountain Press.

David G. Futey, an author and photographer, is a coauthor of *Geology Underfoot in Southern Utah* and a photographic contributor to *Geology Underfoot in Central Nevada*. His breadth of photographic work, which has been selected for juried shows, includes landscapes, florals, and abstracts. He resides in Colorado Springs with his wife, Susan, daughter, Mary, and son, Evan.